Secret Teachings of a Comic Book Master

The Art of Alfredo Alcala

Secret Teachings of a Comic Book Master

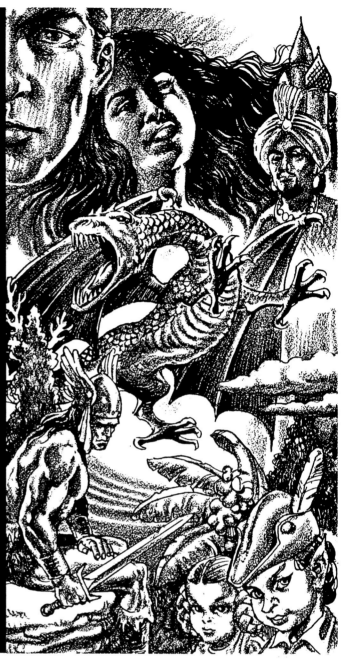

The Art of Alfredo Alcala

Heidi MacDonald
Phillip Dana Yeh

WITH INTRODUCTIONS BY
GIL KANE AND ROY THOMAS

DOVER PUBLICATIONS, INC.
Mineola, New York

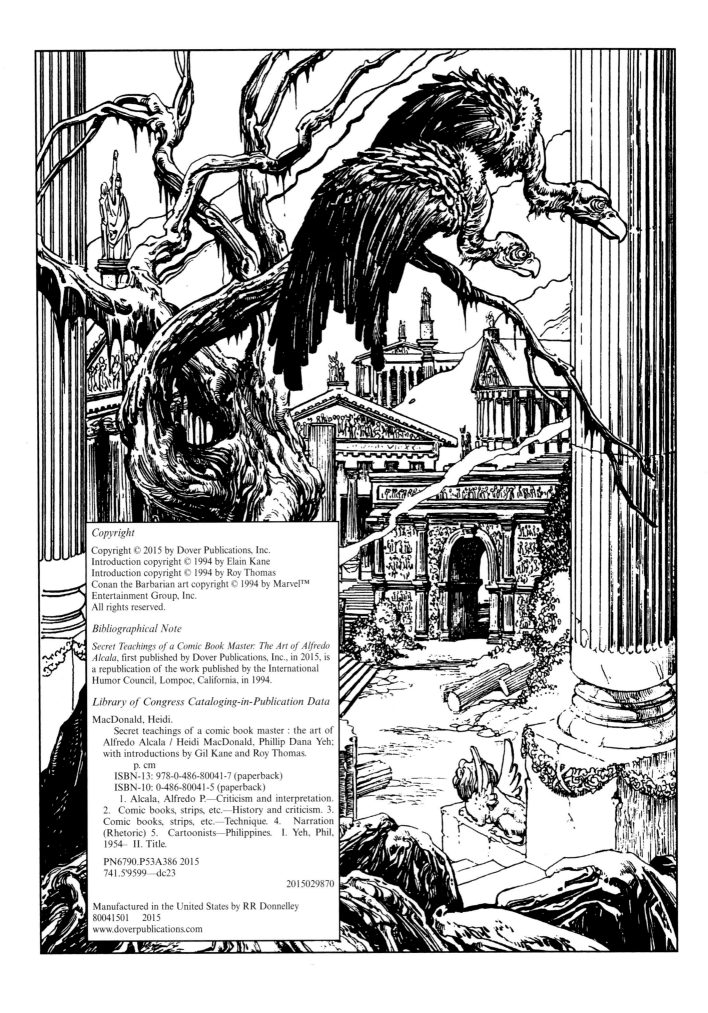

Bibliographical Note

*Secret Teachings of a Comic Book Master: The Art of Alfredo
Alcala*, first published by Dover Publications, Inc., in 2015, is
a republication of the work published by the International
Humor Council, Lompoc, California, in 1994.

Library of Congress Cataloging-in-Publication Data

MacDonald, Heidi.
 Secret teachings of a comic book master : the art of
Alfredo Alcala / Heidi MacDonald, Phillip Dana Yeh;
with introductions by Gil Kane and Roy Thomas.
 p. cm
 ISBN-13: 978-0-486-80041-7 (paperback)
 ISBN-10: 0-486-80041-5 (paperback)
 1. Alcala, Alfredo P.—Criticism and interpretation.
2. Comic books, strips, etc.—History and criticism. 3.
Comic books, strips, etc.—Technique. 4. Narration
(Rhetoric) 5. Cartoonists—Philippines. I. Yeh, Phil,
1954– II. Title.

PN6790.P53A386 2015
741.5'9599—dc23
 2015029870

Manufactured in the United States by RR Donnelley
80041501 2015
www.doverpublications.com

Special Thanks to:
Manuel Auad
Cheryl Navratil
Steve Herrington
Nina Paley
Joan & James Staffen
Chris & David Meek

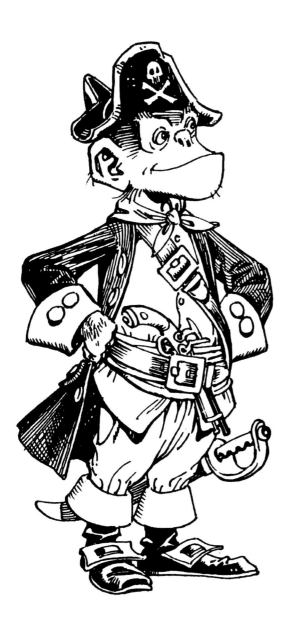

Introduction

By Gil Kane

Alfredo Alcala is one of the most disciplined and perceptive artists inking in comics.

During his best work, on the early black and white *Savage Tales*, which featured Conan, Alfredo achieved levels of tonality that I have seen equaled only by the engravers who worked over Gustave Doré.

When we both worked for the Ruby Spears animation company, I had the pleasure of seeing Alfredo render a presentation I had drawn into a black and white tone poem, in his classic style.

The years of distinguished work have earned Alfredo a special place in comics history.

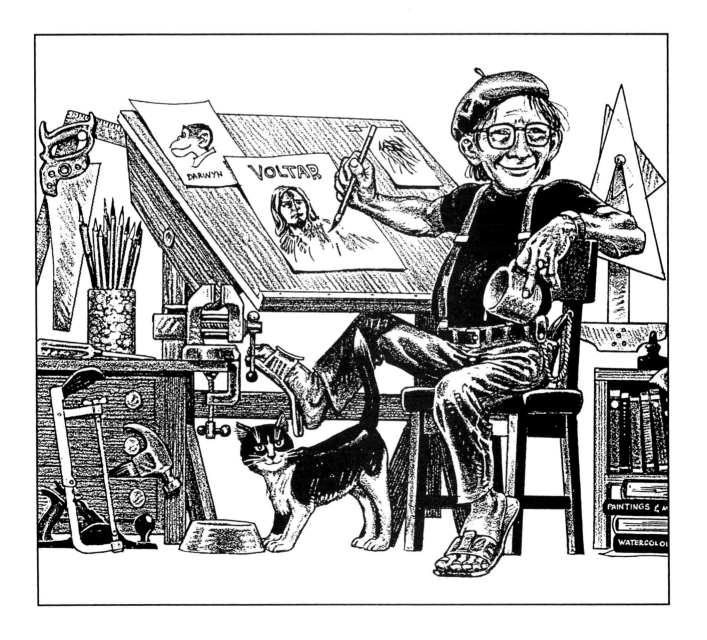

"A" is for Alfredo

A Personal Reminiscence by Roy Thomas

What can you say about a man who's had a comic book named after himself, and the whole schmeer?

Well, for one thing, you can say that he's probably one of a kind.

And that, Alfredo Alcala definitely is.

My own recollections of Alfredo and his art, of course, don't go back to the halcyon days when *ALFREDO ALCALA COMICS* was published in his native Philippines. As with most Americans, they begin when he and a handful of other amazing Filipino comics artists began to appear in the pages of DC's "mystery" comics, through an agency established by Tony and Mary DeZuniga.

In the late 1960s, all of us in the field were suddenly knocked out to learn that there were so many talented artists, and indeed an entire comics industry, flourishing in that island nation. Tony himself was one of the premier illustrators, as were a few others, which included Nestor Redondo and Ernie Chan.

And no one made a bigger, or more lasting impression on U.S. comic art than Alfredo Alcala.

Not only could he draw exceptionally well, and tell a good story (two things many comic book artists in both countries were less adequate at than you might imagine - and still are), but he embellished his art with a detailed and thoughtful inking style which nobody ever mistook for anyone else's.

It's not simply that there were a lot of lines on the paper. That's easy enough to do, if you

take enough time (though Alfredo was fast, to boot). It's that the lines made sense. They gave a texture and an integrity to a comics page that made it Alfredo's own. One of the illustrators he was most often compared with, and not unfavorably, was Gustave Doré, whose visions of Don Quixote, the Bible, and other classic subjects are immortal. Alfredo brought much of that same style and elegance to the DC comics.

So naturally, we were happy to "swipe" him for Marvel when the opportunity came along.

I honestly can't remember whether Alfredo did any work for Marvel before "Black Colossus" in 1974's *SAVAGE SWORD OF CONAN* #2; but it doesn't much matter if he did. For it was his teaming with the penciling of John Buscema which suddenly put him on the American comics map in a big way.

As editor, I'd been looking for a style of art for the new *SAVAGE SWORD* black-and-white comic which would be a worthy successor to the art nouveau-influenced look of Barry Windsor-Smith (then Barry Smith) in *CONAN THE BARBARIAN* and *SAVAGE SWORD*'s Conan-starring predecessor, *SAVAGE TALES*.

I already had the penciler - John Buscema. Nobody in comics ever drew the human form (or much of anything else) much better. But since John preferred not to ink his own work, and often did only pencil layouts, I needed an inker who could not only draw as well in his own way as John could in his, but hopefully one who could give the finished artwork the same profusion of detail as Barry's later work, thus giving an illustrative reality to the stories.

The moment I saw the splash page of "Black Colossus" with Alfredo's inking of John's layouts, I knew I had what I wanted.

The readers responded immediately as well, and a team was born that lasted for quite a few years. "Iron Shadows in the Moon", "The Citadel at the Center of Time", "The People of the Black Circle", "The Slithering Shadow" - almost any page of any of these Conan stories

would be worth printing by itself as a poster.

Along the way, of course, Alfredo has done a considerable body of work, either as both penciler and inker, or as inker of other artists' pencils, which has likewise done him proud. In the Robert E. Howard vein alone, he's done full art on beautiful tales of Conan and King Kull, as well as his own hero, Voltar. Alfredo's linework makes the scenes look so real that you almost feel you could step right into them.

And if anything could ever surpass, in my eyes, Alfredo's work on Howard material, it would be his exquisite renditions for Marvel of L. Frank Baum's *THE LAND OF OZ* and *OZMA OF OZ*. (The latter was never published for various reasons, but I have a copy of most of its 70-plus pages - as well as the original frontispiece for the former.)

I knew, from the moment that Marvel elected to adapt some of Baum's sequels to *THE WIZARD OF OZ*, that Alfredo was the perfect illustrator for them. He performed a difficult task - capturing the style of the major Oz illustrator, John R. Neill, and combining it with the MGM-influenced likenesses of the Scarecrow, Tin Woodsman and Cowardly Lion that we were legally required to do. There are few things in comics that I'm prouder of than my association with Marvel's Oz books, even if they never reached as large an audience as they deserved.

In case you haven't noticed, I'm a fan of Alfredo Alcala.

If you have any taste at all, so are you.

[Roy Thomas wrote and edited *CONAN THE BARBARIAN* and *SAVAGE SWORD OF CONAN* from their 1970s beginnings until 1981, and has been the recipient of the Shazam and other fan and professional awards over the years. he is currently the writer of Marvel's *CONAN THE ADVENTURER, SAVAGE SWORD OF CONAN, THOR, FANTASTIC FOUR UNLIMITED,* and of Topps Comics' *CADILLACS AND DINOSAURS*.]

On the Road with a Real Artist
by Phil Yeh

ALFREDO P. ALCALA 80

If you ever get the chance to hang out with a *real* artist, I guarantee the experience will improve your vision. A real artist is someone who is constantly seeing the world in a unique way. A real artist is always observing. It's like being with a master detective, say, Sherlock Holmes. You are constantly being made aware of every little detail around you. And because you are "seeing" every little detail, you are forcing yourself to commit them to memory. Not a bad tool if your business is making pictures and telling stories.

Alfredo Alcala is a real artist. I will try in this introduction to define what makes someone a real artist. It definitely doesn't have anything to do with money or status or media hype. I will also try to offer a few of the *Secret Teachings* that Alfredo has passed on to me in the years that we have been friends. I have

marked these *Secret Teachings* in **boldface** to allow the reader a chance to commit these items to memory.

Real artists are a very rare thing in the world today. I know this because I have spent quite a bit of time with people who claim to be artists. They dress like artists and they talk about art and use lots of flowery language. But few of these people are truly artists. Most of them are simply caught up with the fashion of pretending to be an artist. They do art because it's their job. They don't really put their heart and soul into their work. In essence, they are craftsmen, not artists. The first thing that I learned from Alfredo many years ago was that art has to come from inside a person. It's not about college degrees or what your friends think. You won't be an artist by wearing cool clothes and hanging out in coffee shops all night. *Secret Teaching Number One: Look inside yourself to find the artist.*

Unfortunately, we have a lot of people who are not real artists dominating the arts in the United States. This probably explains why we have so many bad movies, stupid television shows, trite books, boring music, and schlock comic books on the market today. We're now living in a time when the people with the biggest public relations agency and the most money backing them are declared by the media as "artists" while the few real artists in the world are generally struggling in obscurity somewhere. When one big conglomerate owns the record company, the publishing company, the TV and film companies, the newspapers and radio stations, it just makes good business sense for them to "create" their own "artists". It also makes sense for them to keep the public ignorant about what art is so that they can't recognize that they're being sold a bill of goods.

Alfredo and I have had many a spirited discussion about the way in which the modern

world is turning. We have also both tried to keep our sense of humor when confronted daily with the utter stupidity of modern life in the United States of America.

60 Minutes recently did a story about a New York Gallery selling giant white canvases to rich people for hundreds of thousands of dollars. The gallery owner was on TV explaining to the reporter that in fact the white canvas represented minimalism at it's best. I sometimes wonder if anyone in the United States has ever read Hans Christian Anderson's *The Emperor's New Clothes.*

That's the problem with our media-hyped country in the '90s. It's extremely easy to pull the wool over the public's eyes when it comes to art in the U.S. because most people have absolutely no idea of what ART is in the first place. The first programs cut from the schools are the art and music programs. Art isn't important in this country - we value money over all things.

We don't require our students to take art classes, nor do we encourage it for the most part. The result of a society that doesn't appreciate art is a society in decline. Take a look at our crime statistics and our illiteracy rate in the U.S. and you can clearly see what happens when a society values the destructive process over the creative process. I have always believed that if everyone in this society played a musical instrument or painted or drew or wrote poetry, we would all be better off. People would find better ways to express their anger and frustration. If our society held artists in higher esteem, everyone would be doing art for fun - the way that most Americans play sports or watch TV or shop at the malls.

When I talk about these things with Alfredo, he gives me the wisdom of his years and experience. He reminds me that he always did what he believed in when it came to art. He never tried to follow the crowd. He was looking at old masters and illustrators when his contemporaries were looking at comic book artists. Later, most of the good artists followed Alfredo's example. He has always

stressed that he doesn't create art for publicity - he creates art because he is an artist. *Secret Teaching Number Two: Don't do what's popular at the moment. Create honest art.*

I grew up in the United States and Alfredo grew up in the Philippines. Although we have very different backgrounds and come from different generations, we also share many of the same ideas about the world. From the very earliest time we could both remember, we wanted to draw pictures. Perhaps this is why we hit it off from the start. I met Alfredo a few years before I made my first trip back to China in 1979. It was around 1976 or 1977 - I'm sure that Alfredo can remember the exact date - as well as what we had for dinner and what color shirt I was wearing. I never had quite the memory he does. I do know that meeting and getting to know Alfredo was like rediscovering an old friend from a previous life. I don't know how to explain why some people just seem to feel like old friends right away and others do not. There's no logic in that area.

I was going to China to meet my grandfather and other relatives for the first time. My dad had left his entire family in 1948 and more than 30 years had passed until he was able to go home again. I grew up without being able to really know anything about my father's family. I was told that I would probably never see them or visit China in my lifetime. This situation caused me to read everything I could about geography and history and world politics in order to try and correct this injustice in my life. It also caused me to try and write and draw stories that would bring people together. I felt that I had a mission to tell my stories.

I wasn't that aware of Alfredo's work when we first met, nor did I really know anything about him. He's 30 years older than me and he grew up in the Philippines. Perhaps on the surface, it didn't look like we would become the best of friends. I do know that I liked Alfredo the minute he started talking. He was outspoken

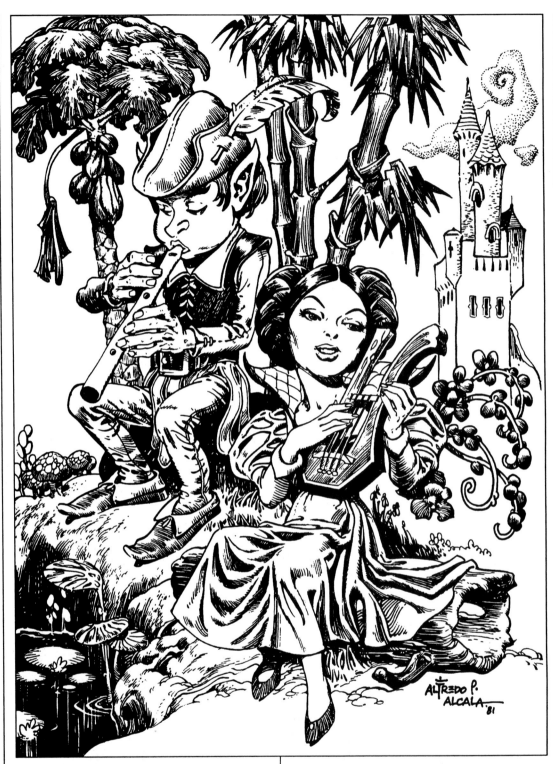

and he had a theory about everything. And he knew his history and his music and his art. I knew that the first time I met Alfredo that he too felt the same way about art as I did. It wasn't a matter of choice, he had to draw.

Alfredo captivated the other artists around him when he told his stories. I know that many times they were more often laughing at him than with him, since many of the professionals in our comic book field think he's a bit crazy. But if being crazy means seeing the world for what it is and not for the myths and lies that people in power shove down our throats, then I agree with them. Alfredo is a bit

crazy. He's also a real artist. I could see in Alfredo's life many of the same experiences that had shaped me. Few people have ever believed that I would do anything of value. If you think differently from the crowd, be prepared for their scorn.

Artists usually have to believe in their vision in spite of the people around them. When Alfredo describes his love of drawing as a child, you can see that the magic is still there all these many years later. He lives and breathes art. He draws and paints all the time. He works longer and harder than any other artist on the planet. I am not exaggerating here, either. He seldom sleeps in a bed for eight hours - instead he sleeps at the drawing table or on the floor for quick cat naps (literally) with his cat - it's one of his theories.

When I met Alfredo I was in my early 20s. I had just opened my own art gallery and I was writing and drawing a lot of books. I was also publishing a monthly newspaper covering the arts. I guess that I saw in Alfredo a real hero come to life. A bit of Don Quixote and a bit of Robin Hood. A completely honest human being who simply did and said what he believed. He dressed as he wanted without any thought to style. He smoked when and where he wanted and he did what he wanted for a living. Alfredo is a person who is nice to anyone no matter their color, creed, or economic status. He doesn't prejudge people. I have witnessed his generosity to total strangers and to friends and to myself in both wisdom and money (when I was broke, he always bought dinner!). But if you prove to be an idiot, or a dishonest person, he has no use for you at all! Best of all, he taught me that you had to be true to yourself on this planet. This

is a lesson that to this day I am still struggling to get right. *Secret Teaching Number Three: Seek knowledge from an older person who has real wisdom.*

We became fast friends after Alfredo moved to Los Angeles from New York. He had originally arrived in New York City from the Philippines in the middle of winter. It was the first time he had ever seen snow. He had left a tropical country and arrived in the middle of a blizzard! Once he got to L.A., we saw each other all the time. He spent many days and nights at my gallery-studio in Long Beach and even more hours on the telephone. I remember the phone company cutting off his phone because his bill was so high the first month he moved here! He loves to talk for hours to his family in the Philippines, which at first panicked the phone company people - they didn't believe that he could pay the bills! If you know Alfredo, you know that he always pays his bills.

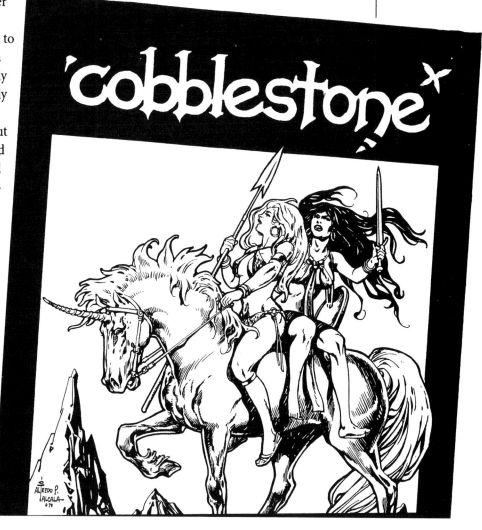

I remember the first time I saw him pick up a pencil and go to work. After laying out the page in pencil, he would pick up his brush and begin inking. He didn't get up from the chair to watch TV or eat a snack. He sat at the drawing table and he did the work. And that's why he gets more work done than 99% of the artists in the world. *Secret Teaching Number Four: Sit down and work and you will finish the job.*

I suppose what makes a good friendship last for many years is that fundamentally, two people agree on the big issues (and probably a lot of the smaller ones as well). This is the case with Alfredo and I. I have never had to explain why I am

frustrated about the stupidity, the violence, the racism, and the injustice that dominates the culture of the U.S. He understands.

Alfredo and I talk about things all the time. He has been the one person in my life who has always understood my passion for learning and for real art. He has also been the one person who understands the role that racism plays in the art world - just as it plays a role in all facets of American life. But we both agree that a real artist doesn't work for society's approval. Let me paraphrase Secret Teaching

Number One - *Real artists create for themselves. You have to be true to yourself.*

Today, I live 150 miles north of Los Angeles in the country, and Alfredo and I don't see each other in person as often but we still have our six hour phone conversations. I still haven't found anyone else on the planet who understands me better than Alfredo. I wanted to put this book together because I think a lot of young artists might benefit from Alfredo's special wisdom. This isn't a story that you'll read in an art history book, or see on a bookstore rack in the "How to Draw Exactly Like..." section.

This very different book has taken a long time to come together, a lot longer than anyone thought. Alfredo wanted to make this really special, so he painted a big beautiful new painting just for the book's back cover. I spent a lot of time going over stacks of his artwork, writer Heidi MacDonald transcribed the many hours of her interviews with him, and our editor Edmond Gauthier spent a lot of time processing all this information and then our designer RC Williams laid this book out in his own unique style.

When we began this project, Alfredo was going through a period of his life when he wasn't doing a lot of comic book work. The majority of the new batch of editors have short memories and little respect for age and wisdom (are they any different from the rest of youth-obsessed America?). I wanted this book to serve as a history of one of the world's real comic book masters (no media hype, just the truth).

This project began as Alfredo was approaching his 68th birthday but he wasn't slowing down. In fact, when I took him to dinner to celebrate his birthday this past August 1993, he told me when we got to the restaurant that he had been having birthday celebrations with various friends at that same restaurant for four days in a row! (It was a 24 hour Chinese restaurant in LA's Chinatown - the perfect place for either one of us. Chinese food at any hour, a dream come true!) *Maybe*

Teaching-Number Five: Travel light and always carry your art supplies. But no, I had the luggage and that heavy metal card rack!

We collapsed in our berth and Alfredo lit a cigarette. I noticed that the windows didn't open and I wondered if I'd survive the trip, since I don't smoke. The porter's name was Sam and he reminded me that he had met me a couple of weeks earlier when I'd taken the same train to San Francisco. I told Sam that I had really enjoyed the trip and that I wanted to experience a longer journey with my friend Alfredo.

After a few hours, we were north of Santa Barbara in the beautiful oak covered hills that make up the area of San Luis Obispo. It was a really great day. Alfredo lit up another cigarette and told me about riding trains in the Philippines during World War II when the Japanese occupied his country.

The Filipinos had to sit on the roofs of the trains, he tells me. I ask if anyone ever fell off.

Santa Barbara

that's why we're such good friends! Of course, after having a late Chinese meal, Alfredo wasn't going to bed early, he was spending the rest of the night until dawn hanging out with many of the hot Filipino artists, actors, writers, and filmmakers in LA in a variety of trendy coffee houses. Most of these folks were 30 to 50 years younger than Alfredo, but I know that he still has more energy than all of them.

I've traveled with the man and I speak the truth when I say that he doesn't sleep! Back in 1980, we took a train trip from Los Angeles to Seattle that I will remember as long as live. It was a journey worthy of a Kerouac novel. It really does seem like yesterday.

We jumped on the train at 10:00 a.m. in the middle of January. When I say jumped, I mean jumped. The train was starting to leave the station and Alfredo and I were running down the landing to catch it. And to make it more of a challenge, we were loaded down with luggage and a heavy metal card rack! Alfredo and I were on our way to appear at a Science Fiction Convention arranged by our dear pal Jerome Poynton, who was our agent at the time (and now a successful writer and filmmaker in New York City).

I shouldn't say that *"we"* were loaded down with luggage. Alfredo had his art supplies and a portfolio. He didn't have any luggage. He never has any luggage. Alfredo doesn't believe in luggage. This is easily *another Secret*

"Of course, but that's life," he replies. Alfredo always takes things as they come, which is a good Taoist attitude. He tells me about growing up in the Philippines and being a spy during the war when he was still a young man. He has told me these stories many times but I always find myself seeing some new detail for

The rolling hills of San Louis Obispo

the first time when he describes what happened to him during the war. He learned to write in Japanese script to create fake passes for himself. If they had caught on they would have executed him - so his Japanese had to be perfect! He rode around on a bicycle and memorized Japanese gun positions and later made maps for the underground who got the messages to the American bombers. When the bombs fell, Alfredo would point and tell his friends where they would land. After all, he was the one who gave them the information! *Secret Teaching Number Six: Learn to observe everything around you - it may save your life someday. Or who knows? Maybe also the life of your country.*

As the train continues through the California farm lands that make up so much of this state, Alfredo looks out the window observing everything. He's makes sketches for my newspaper article about our trip. We decide to go to the observation car after eating lunch, since you can see both sides from this car with it's glass domed roof. Alfredo and I have both brought along some watercolor card stock to keep ourselves busy on the trip. As we look out the window at the beautiful trees and rolling hills, Alfredo starts to sketch some cards and also do more illustrations for the article. He's

drawing everything, from the natural landscapes to the factories.

The other passengers in the observation car begin to notice us as we paint and draw. Soon, we're getting offers from the other passengers for our work and making a little bit of dinner money while we enjoy our trip. Alfredo reminds me that he made money with his art when he was still in elementary school in the early 1930s by creating special notebook covers for his fellow students. It was better than being a shoeshine boy because he was truly doing what he wanted.

Alfredo didn't like school. Actually, he didn't like a certain teacher in school. He has never been one to follow rules nor spend his time listening to people he thinks are wrong. Many of us who have become cartoonists and artists have had bad experiences in school. Some teachers don't understand artists or anyone who doesn't follow the "normal" crowd. If you look at the history books, most of the outstanding people were usually considered poor students. I'd like to think that this has changed today as we get more enlightened teachers (and I know that there are some today) but it wasn't the case when Alfredo was growing up. If you didn't follow the rules, you got kicked out. He had one run-in too many with this teacher and was thrown out of school at a very young age.

Even though Alfredo never had a formal education, he is still one of the smartest people I have ever known (and I have met a lot of so-called educated people in my life). Alfredo learned the old fashioned way. He READ everything that he could get his hands on. One of the advantages of being a Filipino is that English is the official language of the country. This gives even the poorest Filipino the chance to read magazines or books in English as well as in their own dialects. Alfredo still reads everything he can today. And he remembers what he has read. *Secret Teaching Number Seven: If you really want to be smart, READ on your own.*

I don't want young people reading this to get the idea that dropping out of school or getting kicked out of school is a good idea. It's not. Alfredo's own children have all finished school and have studied very hard. Teaching yourself is a lot harder and takes a lot more discipline. I know that many times, Alfredo feels like some people would respect him more if he had some sort of college degree. But I also know that through Alfredo's reading and life experience, he has much more knowledge about art (and a lot of other subjects) than any hundred college professors.

This is probably one of the reasons that Alfredo and I are such good friends. We both had pretty rocky school experiences (we didn't fit into the mold) but we both love to read and talk about history and the world. We also share a deep passion for metaphysics and philosophy. And Alfredo is a near genius when it comes to the subject of classical music. I have watched him have wonderful conversations with gifted musicians and music lovers in our travels (I have little idea as to what they are talking about!).

Alfredo can also name the stunt people in the films that he watched as a youth. He loved the comedies of Chaplin and Laurel and Hardy and all the famous adventure films of the day. A friend of ours was actually working on a book of old Hollywood stunt people and I recall Alfredo and him having this animated conversation about who did what stunt in what film in the '30s and '40s! Watching movies helped Alfredo learn to draw. He paid attention to the little details - pity the poor director who hasn't edited a scene correctly - and to this day, he can tell you where there was an error in an old film.

These old classic films are great places to study costumes, pacing and other facets of good story telling so important to a comic book artist. But I have to stress that you have to watch GREAT movies to really learn anything. I myself was a film student in college and I can attest to Alfredo's belief that most

movies today are basically worthless. Alfredo stopped going to movies because he can't smoke in the theater, so he stays home and resorts to cable TV.

Secret Teaching Number Eight: When reading or watching a film, learn to think like the director or author. This will help you in breaking down stories for comic books.

Since Alfredo loves to talk about his favorite old movies, he is really enjoying the train ride up to Seattle. We sell a bunch of cards in the observation car and then go back to our berth to get ready for dinner. I start to think that maybe I could spend the rest of my life traveling around the world in trains with my paints. The sun is starting to go down, and he now talks about his childhood again.

Alfredo reminds me that one of his first jobs was working at a wrought-iron shop designing chandeliers, garden furniture, table lamps and even a church pulpit! After work, he would study and copy the illustrations of Harold Foster's *Prince Valiant* and Alex Raymond's *Flash Gordon*, often going practically sleepless in his ambition to become a "komiks" artist.

A Brief History of Filipino Komiks

I should talk a bit about the komiks *(this is the way they spell the word in the Philippines)* to give you a better perspective of what Alfredo Alcala accomplished in his lifetime.

Most Americans have little knowledge about the vast wealth of comics history that is in the island nation of the Philippines. This diverse country of many dialects - and even more islands - traces its interest in cartooning back to one of its national heroes, Dr. Jose Rizal. Filipino history credits Rizal in 1886 for drawing the first comic strip that saw publication. It was called *The Monkey and The Tortoise* and definitely ranks as one the earliest cartoon strips in the world. Let's put this into perspective for Americans: it would be like saying that George Washington or Thomas

Jefferson were cartoonists, such is the high place in Filipino history that Rizal holds.

Maybe if our own founding fathers had really been cartoonists, this country might hold the cartoon art form in higher esteem today. I am forever reminding my fellow Americans that Paul Revere was known as a cartoonist (as well as a silversmith) and that in fact, an engraving he did of the Boston Massacre was used by Samuel Adams and other patriots to incite early colonists against the British. So this engraving was really one of the earliest editorial cartoons!

Filipino artists were creating one panel and editorial type cartoons since the turn of the century. In 1929, *Liwayway Magazine* added a regular komik strip feature called *Kenkoy* drawn by Antonio S. Velasquez, generally considered the father of Filipino Komiks. During the time of the Japanese occupation, little of the local media survived, although the Japanese allowed *Liwayway Magazine* to continue publication with *Kenkoy* as

the only strip to last throughout the war.

After the country was liberated by the American forces, the Filipinos were exposed to many of the GIs' American comic books at that time. Comic books as we know them only came about in the 1930s. The post-war era created a renaissance in the art form in the Philippines with the formation of Ace Publications and the birth of *Philipino Komiks* in 1947. Tony Velasquez was later one of the originators of *Philipino Komiks,* a place where many of today's most famous Filipino artists began their careers. In 1959, the College of Fine Arts and Architecture of the University of the Philippines invited Velasquez to speak to the student body about cartooning and the birth of the Filipino Komiks Industry. It would be a decade before the same kind of recognition would begin to be seen in the U.S. with the efforts of Shel Dorf's early comic book conventions (the San Diego Comic Book Convention will celebrate its 25th anniversary in 1994).

Alfredo had tried to draw as much as he could during the war years. He illustrated tents, he drew soldiers and he practiced his craft with the help of any illustrated book or magazine that he could find. At one time, American magazines such as *Colliers, The Saturday Evening Post* and *Liberty* (among others) used some of the world's best illustrators to grace their pages. Prior to World War II, American newspapers ran beautifully drawn full page comic strips like *Little Nemo in Slumberland, Tarzan* and *Prince Valiant.* Sadly, there is little space in today's newspaper comic strips for any drawing at all.

Alfredo found inspiration in the work of the great illustrators, such as Dean Cornwell, Howard Pyle, N.C. Wyeth, and J.C. Leyendecker. But it was the work of the British muralist Frank Brangwyn who influenced him the most. On my first visit to Great Britain in 1984, Alfredo made it clear that I should see one of Brangwyn's murals on public display (it took us a few hours to find this place, but was well worth the hunt!).

In 1949 Alfredo worked on an independent comic book called *Bituin (Star)*. Finally, his dream of being a professional illustrator had come true! Within a few months, he was hired to work on the new *Pilipino Komiks* for Ace Publications, thus beginning a professional career that would make his artwork known around the world. Alfredo worked on his scripts for the komiks without any assistance. He did all the penciling, lettering and inking himself. Unlike most American artists who work with a number of assistants, Alfredo learned his craft by doing every single part of it himself. This often meant that he would go for days with hardly any sleep in order to meet a deadline. Another strange thing about the komiks in the Philippines is that many titles appear on a weekly basis, compared to the monthly and bi-monthly schedules in the U.S. It's therefore no surprise that most of the Filipino artists working in the U.S. are much faster than their American counterparts. Komiks were the major form of entertainment for millions of Filipinos after the war and they required their stories on a weekly basis.

Alfredo's desire to bring the level of his comic book work up to the best illustrators continued through the 1950s. His work earned him praise from even the most severe art critics. His epic story about a Native American, *Ukala,* was even made into a motion picture.

He continued to work for Ace Publications until February 1963 when a printing industry strike closed up most of the comic book companies. Alfredo and a few other artists decided to start up their own publishing company, and in April, *Alcala Fight Komiks* was born. That same year, Alfredo began his most famous creation, *Voltar.*

I'll quote from noted art historian Orvy Jundis's article in the *World Encyclopedia of Comics* (Chelsea House/Avon 1976-77) to describe the impact of *Voltar* on the comic art form.

"In the history of the comic book medium there have been many notable features that have become classics in the field. Most of these strips have been team efforts, with several people doing different facets of the production. Certain individuals do the scripting, breakdowns, penciling, inking, lettering and publishing. The exceptions to this method, of course, are the underground comix that are generally one-shot affairs slanted towards a specific audience. Voltar *is truly unique in that it was a continuing series geared towards mass readership. It was written, laid-out, penciled, inked, lettered and published by one man, Alfredo P. Alcala. The brush used to ink many of the* Voltar *pages was a special fountain-brush invented by Alcala, thus making the series even more noteworthy.*

"Aside from the background information, what makes the series stand out is the work itself. It is an astonishing display of sustained artistic endeavor. Every chapter contains a spectacular center spread. Each panel is embellished in an etching style that rivals the works of the old masters. Inch for inch, it is probably the most detailed art ever to appear in comic books."

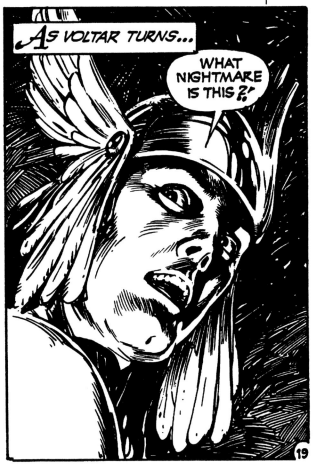

Passing through Oakland

Alfredo's reputation in Filipino komiks history was set in stone in the 1960s. He was the publisher of his own series of comic books and was responsible for introducing many other new talents to the Filipino audience. His years of hard work and constant study had paid off. It was only a matter of time before his work would be discovered by the biggest publishers in America.

When DC Comics publisher Carmine Infantino went to the Philippines in 1972 to recruit new talent, he didn't have to think twice about hiring Alfredo after seeing his work. Within a few years, Alcala would come to live in the U.S. on a permanent basis, working on a wide range of titles that included *Batman, The Hulk, Swamp Thing* and *Conan the Barbarian*. His work on *Conan* is often compared to his work on *Voltar*. It should be pointed out that Alfredo's *Voltar* predates the Conan comic book series.

Meanwhile, back on track with my train story. It is evening and we are approaching Oakland. Alfredo and I hear a knock on our compartment door. Sam the porter extends an invitation from the conductor to us to be his guests for dinner. It seems that the conductor had heard about us entertaining the other passengers with our painting and storytelling in the observation car. So we don't even need to earn our dinner money after all!

I enjoy a very nice meal with the conductor and listen to Alfredo ask our host about the travels and experiences of his railroad life. Alfredo hates to fly and prefers to travel by train, bus or car. He likes to see the landscape. I know that the conductor was impressed with Alfredo's incredible knowledge of so many different things. Alfredo later makes a portrait of the conductor while we enjoyed our dessert. *Secret Teaching Number Nine: Learn to draw and talk at the same time.*

That night back in our berth, I try to get some sleep. Alfredo is restless. Unfortunately, the public cars don't stay open all night. The cigarette smoke is starting to give me a headache (this is the first time we have traveled on a train together). I wonder if the windows could somehow be forced open, but I know there's no way. In the middle of the night Alfredo wakes me up to tell me that we have crossed the California border into Oregon. He is excited. I look outside and all I see is the pitch blackness of the night. "Yeah, it looks like Oregon, " I sleepily reply.

When we get to Seattle, it is freezing - after all, this is January! Our dear friend and then agent Jerry Poynton takes us to an exclusive cocktail party in honor of the director Robert Wise, actor George Takai and us at the top of the Seattle Space Needle. This is my first trip to Seattle and I am impressed that we don't have to pay to ride up the elevator. We're guests at a science fiction convention and the Hollywood folks are here to promote the first *Star Trek* film. I am introduced to a millionaire businessman who is a big fan of Alfredo's *Conan* work. He promises to come see us the

next day at the convention but as usually go...he doesn't.

Alfredo is always telling me that we have to get out and meet people, because you never know when you might meet that special patron. I laugh when I think about some of the blatant con artists we have met over the years. One con artist claimed to be film producer who personally knew Marilyn Monroe. He even had signed photos from her to him on the walls of his seedy little Hollywood office. The only problem was that the producer hadn't even been born until after Monroe had passed away.

Another time two young producers tried to convince Alfredo and me to work on their great movie idea for free. They suggested a meeting in a Hollywood restaurant, which we attended, and then they skipped out on the check. More recently, I had a women tell me that she had hundreds of millions of dollars to give me for a film. Then she added that aliens from outer space had directed her to seek me out! Hey, don't sweat the details. Seldom do these meetings ever amount to anything. The entertainment business loves to take meaningless meetings.

If I have learned anything from Alfredo over the years, it is to enjoy the ride, con artists and all. It's definitely an interesting life, even if you're not a millionaire. *Secret Teaching Number Ten: Don't get into the arts for the money - or, as I always advise younger artists, two words - marry well (i.e. find someone with a good paying regular job!).*

The train trip to Seattle wouldn't be our last trip together. Alfredo and I even returned to the emerald city in a rental car a couple of years later. We also took a trip to Arizona one year with *Groo* cartoonist Sergio Aragones for a couple of book signings. And there have been a lot of trips to Chinese restaurants and bookstores. Alfredo collects old books and thinks nothing of spending a small fortune on a book for one illustration or painting that he likes. He is forever surprising me with some new artist (usually long since dead) that he has discovered.

Sunny Seattle!

Alfredo and I worked together artistically only once. It was in 1980, after that Seattle trip, at a time when we were both appearing at a lot of comic book and science fiction conventions. I decided to create the ultimate dragon drawing, and Alfredo's beautiful inks really brought my pencils to life. We had giant prints made on watercolor stock and I ended up hand painting them at various shows for the next year. Of course, Alfredo has always contributed to my various publishing enterprises, from *Uncle Jam* (a monthly newspaper in California) to *Cobblestone* (an arts magazine). I could always count on him for brilliant covers and illustrations for articles.

To this day, I don't understand why more American newspapers don't employ great illustrators to grace their tired pages. Of course, I don't understand why they don't run the comic strips bigger (like they used to) either! Heaven forbid that it might actually increase their circulations and the literacy rate of this country!

The years have gone by quickly.

Alfredo and I have spent many hours on the phone talking about life and his family in the Philippines. I finally got the chance to visit his wife Lita and their two children on a trip to Manila in 1985. I really felt like I knew them, even though it was the first time we had ever met. We also talk a lot about doing more painting. It's something that we both love. In the last few years, Alfredo has spent more and more time painting brilliant pieces in oil, between his comic book assignments. These works have been shown in various galleries and public exhibitions in California.

As this book goes to press (April 1994), Alfredo is again busy on a variety of comic book projects, from *Conan* to *SeaQuest* to *Ultraman*. Whenever editors need someone that is going to get the job done on time and in a consistently professional manner, they turn to Alfredo's magic brush. As a result, he is almost always working.

Through the years, I have listened to Alfredo tell me his thoughts about the world and his dreams. I know that he is frustrated that more people in this country don't appreciate good art. We talk about it all the time. I share the same frustrations. One of the reasons that I wanted to put this book together was to allow Alfredo to hopefully inspire someone reading this book to bring back great art to the American culture.

Alfredo's story is really the great American dream. A young boy from a poor family without any formal education works hard to pull himself up to international fame. The old cliché about practice makes perfect holds true in this case.

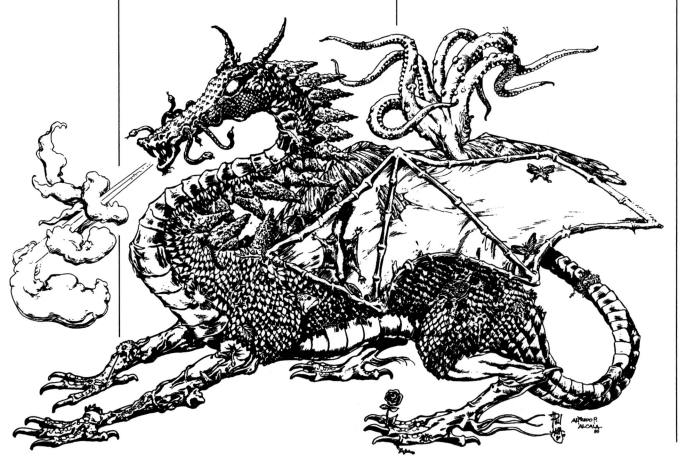

The Art of Observation

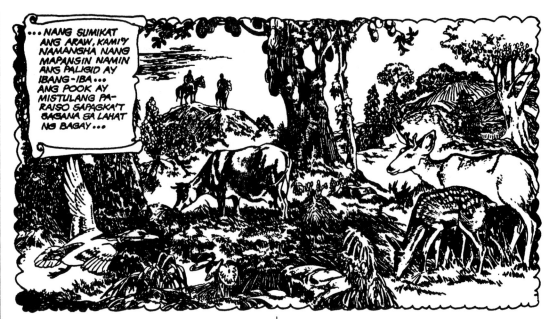

For Alfredo Alcala, the first step in becoming a good artist is a simple one: look around you. "The best advice I would give to an artist is to observe reality. Look at everything around you, people, trees, cars, animals." Learning to draw is really nothing more than the ability to translate what you have seen to paper, according to Alcala.

The key to being able to draw anything anytime is observation. Alcala uses the trick of drawing in the air with his finger, tracing the outline of what he sees. Then he goes home and tries to draw it with a pencil. Alcala has a phenomenal photographic memory, but everyone can benefit from this trick. By copying the shape, you commit it to memory. It's this observation/memorization process that leads to knowing the secrets of proportion (which we'll get back to in a later chapter).

"Try this. Look at a table and notice the shape of it. Now make a drawing of it. The drawing might not be accurate. Why? Your memory can't retain the shape. Now, outline a drawing in the air with the hand. That way it registers in your head. Try drawing it again. The drawing should be more accurate. When you follow it with your finger you are already drawing the shape. You've memorized it.

"It's like a cartoon, in that you see everything with a shape. Don't just look at it. Trace it with your finger. Then draw it out." (In fact,

Alcala makes such a habit of mid-air doodling that sometimes he covers his hand with a napkin so people won't notice!)

The ability to draw from memory begins with drawing from life. Sketching what you see is perhaps the single most important part of learning to draw. By all means, take a regular life drawing class, but don't stop there.

Living in the city, Alcala points out, you don't often see a camel. However, there's nothing wrong with going to the zoo—it's all for art, after all. "If you want to draw a camel, observe one, try to memorize the proportions. That way you can draw it anytime."

In order to sharpen your eye, Alcala advises, "Always look at live people, the live, real ones. Don't think about drawing an ear, look at someone's ear. After you've doodled in the air, doodle on paper to see what you've learned by doing it with your finger. You notice that your drawing resembles what you looked at. That's when you know you've got it.

"That's only an exercise, though. The main thing is to *apply* everything directly. If you're a painter, what you paint is yourself - you only change the face or the figure - you insert yourself into the feeling you're trying to portray."

Of course, the other secret to good drawing is practice. "You must draw constantly. Even if you make mistakes, in time you'll know what you're doing wrong, and be able to

correct yourself. Later on you'll see that your vision is improving, and so are your ideas. Don't stop! Draw whenever you get the chance."

Alcala is well aware that there are many distractions for an artist. "If you can spend four hours a day drawing, that would be wonderful. But don't waste time watching television or goofing off. You'll go home and you'll have only half an hour to draw. Spend more time drawing than watching television. I prefer to just listen to the radio when I'm working, because I'm not using my vision, I listen to the music. When you watch TV, you look at the picture, and you forget your drawing."

Once you have begun to truly *see* the world around you, you can begin to translate that into a style of art that is really your own.

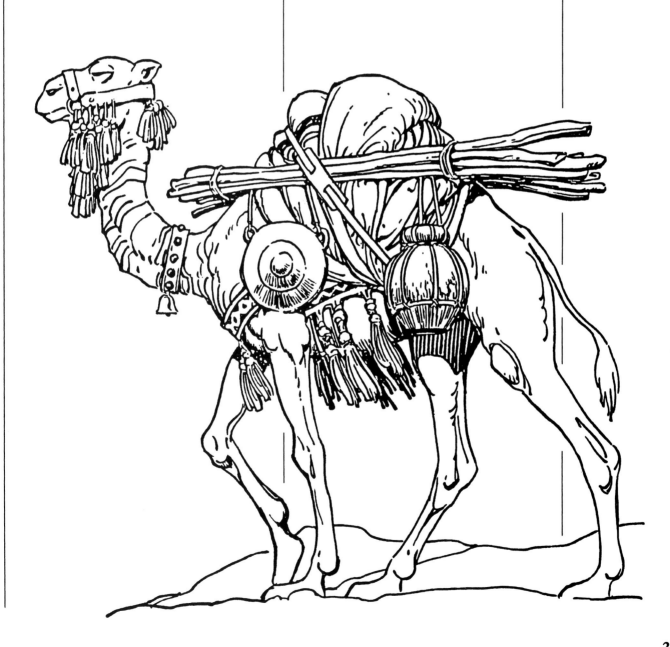

Discovering Your Style

"As you go on you will discover what you like to draw," Alcala continues. "Maybe it's animals, or landscapes, or the human figure. You might like superheroes. When you're just starting out, you're just playing around, discovering the surface. Then you may discover what you love to draw. Perhaps you love landscapes. Because you love it, you might not pay as much attention to other kinds of drawing, such as architecture."

At first, young artists have a tendency to want to do everything, Alcala says. "I say, kid, you like everything. You see one artist and you want to be like him but then you see some one else and want to be like that. You see a comic book by someone you admire and say 'I ought to be like him.' You'll see a magazine, and say 'Why, I ought to be in a magazine or newspaper!' In the beginning, young artists always want to do everything, but as you go along, you will discover what you love, what you really love. Still, a good artist may have a specialty, but he's still a total artist.

"You also learn what medium you prefer: oil, charcoal, pastel, or pen and ink. Don't imitate your friend the artist, and say I want to be like him. You may not have a natural aptitude for a certain medium, while the person you admire does. So don't just try to imitate the other artist.

"That's the final step in becoming an artist. You can have all the technique in the world, but when at last you put it into your own vision, which no one else could see, that's the ultimate."

In Alcala's own case, he learned that the more photographic, or realistic a drawing was, the less he was interested in it. "But the more decorative it is, the more I like it. I like stylized art."

"I like to draw people. I also like to draw unusual genres. I've always tried to get away from the commonplace, from whatever was flooding the market. When I started doing sword and sorcery, only a few people were doing it; later on, many people were doing it."

Of course, even though young artists must strive always to develop an individual style, there is still a great deal to be learned from artists of the past. In particular, Alcala studied the great illustrators, such as J.C. Leyendecker and Dean Cornwell.

"Their thinking was so wide. Leyendecker was very decorative and good on the eye, but I feel more for Cornwell. His atmosphere, layout and action all have tremendous movement. Many artists may make the figures in the foreground lively, but the people in the background just stand around. Cornwell doesn't do that. Everything moves!" Cornwell also excelled at playing with light and shade.

"I like Leyendecker for his decorative, unusual art. He was very stylized. I like the variety in his work. Cornwell is more of a colorist. He played with color a lot in his composition. He didn't do what you expected him to do. A simple landscape, a tree, a meadow, everything became interesting when he painted it."

Once again, this is what makes a true artist: someone whose vision surprises the viewer. Even with all his artistic vision, Alcala "cannot imagine what Cornwell imagined. I can't think the way he did. He twisted everything. An uninteresting thing became interesting. But I don't know how he did it, how he saw it. He knew how to play

SUBALIT MAKALIPAS ANG ILANG SAGLIT, AY...

with color, how to take a dead do-nothing object and make it a colorful, living shape. "

Among comics artists, Alcala mentions Gil Kane, Joe Kubert and Alex Toth as some whose storytelling and layout stand out. "Kane maintains proportion, and is an excellent storyteller. His figure drawing is consistent. He maintains quality, that's the most important thing. He's also an intelligent guy. When an artist is smart, you can tell it in his drawing."

He also mentions the late Lou Fine, who drew comics back in the 40s, and was a major influence on many of the superhero artists of the 60s. "He was very good and very observant. His anatomy was outstanding. I heard that Fine was always in the gym watching people working out with barbells, and so on. He didn't render for the sake of rendering, but you could see the contours. Lou Fine is one of my idols. Oddly enough, it turned out that my list of idols is almost the same as Lou Fine's. I told Nestor Redondo that my idols were Brangwyn, Cornwell and Leyendecker. Later on, I saw a list of Fine's idols, and it was identical."

The young artist must never forget that learning to draw is an ongoing process which never really ends. Alcala refers to a story about another one of his artistic influences Frank Brangwyn. "The great Brangwyn was always observing. Even when he was out with a girl, he wasn't just out with a girl in the moonlight. He studied the color, the blending of the moon and her skin. So he had a dual purpose: Dating the girl plus studying the color of the skin in moonlight! When I heard this story I said to myself, 'Wow, I'm not thinking of that, but from now on I'll look!'

"Always observe. Never stop. I'm at an age when you would think I know everything I need to know, but I never stop buying books. I always want to learn more. I'm not a good artist—yet. I said 'Yet.' I still wish to improve, to learn even more. Never stop. Once you think 'I'm a good artist,' that's the end of you. I never call myself a good artist. I've still got to learn. A lot of young artists don't bother to observe the world around them; instead they

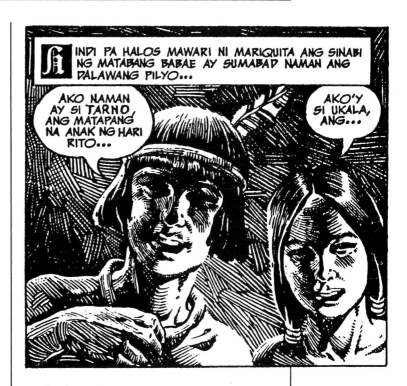

just look at other artists. Nobody tells them what to do. They became comic book artists, but because they haven't studied, they don't even know that their drawings are out of proportion.

"Unfortunately, they stay that way because nobody tells them that they are out of proportion. Even the editors that work on their books don't know how to look at drawing. Understanding something isn't the same as knowing how to do it. I understand juggling, but I can't juggle. Other people understand swimming, but they can't swim. Most comic book editors are used to dealing with story, but they don't have a background in art. I believe an editor should also know how to draw, otherwise they won't be able to criticize the drawing on a page.

"If an editor says, 'Oh, that's okay,' then they spoil the young artist. The young artist says, 'Oh, I'm great' and the editor says, 'I'm great.' Later on as the artist grows older he or she finds out they can't do anything but superheroes. Most artists want to change when they grow older, and move into painting or murals or something different. But if they haven't had the right training, they'll have a difficult time of it."

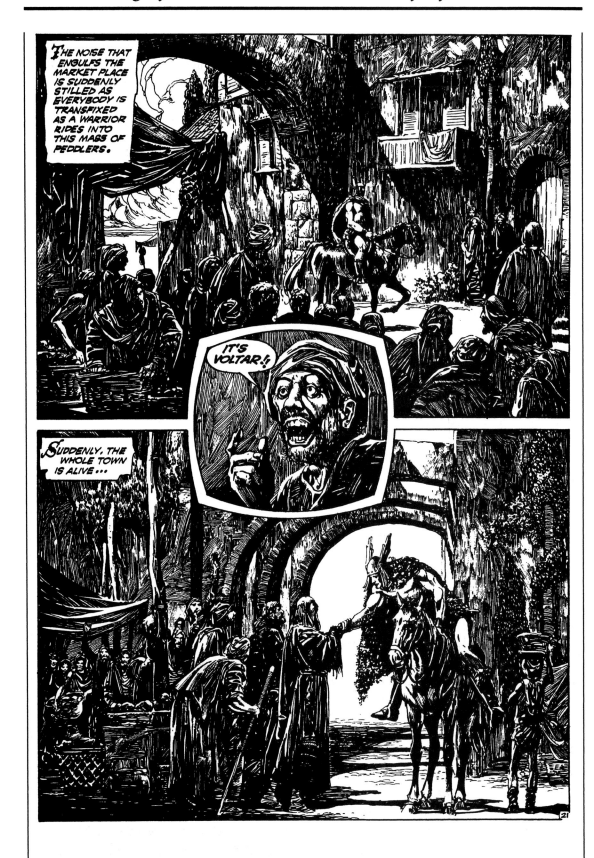

Tools

While drawing skills are the basic building blocks of the artist's trade, the young artist also needs a working knowledge of the tools necessary to get the job done. The essential tools of the artist's trade are the pen, brush and pencil.

The pencil should be the first to be mastered. "Start out drawing carefully with a pencil, until you know how to draw with it. An artist must not jump right away into ink. When you've gotten the feel for a pencil and gained some skill with it, then you can start inking on top of the pencil. The secret is to not be in a hurry to ink a sketch. First, be sure you've done what you wanted in pencil. A pencil sketch is easy to erase when something's wrong, but ink is not! So it's better to be certain in the pencils."

Most readers are probably already familiar with the range of pencils available in an art store. They come in two kinds of leads: H (hard) and B (soft), and range from 6H to 6B. The higher the number, the harder or softer the lead is. An HB pencil is somewhere in the middle, as you might expect. The softer the lead, the darker the line, but very soft leads also have a tendency to smear, so an artist must get used to the various lines that each kind of pencil can produce.

"A #2B pencil is okay, but if you want a darker shade, you can go up the to the 6B," Alcala advises.

Once you've finished a drawing in pencil, the biggest question is whether to use a brush or a pen. Each has its own adherents, but to be a complete artist, you should be familiar with both. Alcala usually uses a brush. His favorite is a Chinese brush, but he finds them hard to locate in America. "I feel it's better to use an American brush. If you want to use them for inking, my recommendation is the No. 2, 3 or 4 for drawing. For watercolor you can use a bigger brush, but only for watercolor."

Of course, artists will go back and forth on the difference between a pen and a brush. "If you're in a hurry to draw, you'll do more faster with a pen, because a pen is more stable.

You can have it flex like a brush, but when you do the erasing, you're going to almost remove the ink. A brush line holds on the paper. With a pen you can stipple. A brush can run, but you have to use a very fine line to a stipple. A brush is much harder to learn, because it's soft and harder to control. At first, just use the brush for applying a heavy shade to darken the background, but don't try it on figures until you've really learned to control the brush."

It may take some time to master inking with a brush. As always, practice is the key. "Try different strokes, downwards, sideways, upwards, over and over, until you get the feel of it. With a pen you don't need as much practice. It's like holding a pencil. But with a brush it's harder to feel secure. You must learn to hold it gently. Don't hold the brush as if you're holding the pencil." Alcala uses a sable brush. "It's expensive, but it's worth it."

However, it's important to be versatile. Alcala stresses the importance of not being just one type of artist. "Don't be a pen artist or a brush artist, use them both." This improves not only your artwork, but your ability to do different kinds of jobs.

Alcala has long been known as an innovator, even to the point of inventing his own tools. When he started working on his famous book *Voltar*, he invented a kind of fountain brush—he combined the barrel of a fountain pen with hair from a Chinese brush, to create something like the nylon markers which you can purchase in any art store today. Except that Alcala did it way back in 1963!

"It had a more even flow of ink than a regular brush," he recalls. "I used it for rendering. I didn't have to dip it, which was the advantage over a regular brush."

In addition to the actual drawing, the choice of the paper you draw on can be more important than you may think. "Don't use a rough paper when you're working with a brush. It's as if you're working on sandpaper and you'll wear out your brush. If you're working with a pen, use rough paper, but on a smoother paper the brush moves more evenly.

If you use a rougher paper, your line is not continuous; it jumps. You can't go with the grain. On smooth paper, you run the ink, and the line is continuous."

Unfortunately, the needs of a penciller and inker are often completely different. Pencillers like to use a rough paper, since the rough texture gives a bite for the pencil. The Bristol board commonly used is really not good for an inker, as the rough surface makes pens harder to control, and ink flow uneven. "An inker can have a hard time on Bristol board. Sometimes I use a light box and transfer the finished art to a different paper. Put the rougher pencils on the light box, and put a smoother paper over it, then trace the art with a brush."

One other essential tool that the young artist may not have thought of is the reference library. "The more books the better. An artist needs books on many different subjects, everything from A to Z. Animals, cars, trucks, airplanes, and anything to do with the water." Not only can these images spark the imagination, but they are also invaluable under working conditions. "Being able to get proper reference is especially important for comic artists, who never know what they may be called upon to draw. You need reference on people around the world, different races and cultures from Africa to China and beyond.

"Suppose the story is from Alaska and you have to draw Eskimos. What do you do if you're not an Eskimo? Eskimos have their own unique faces, and clothing, and of course, they live in igloos. They're very husky, round, robust people, and you need to be able to capture that. The young artist needs to read and observe. Remember, what you're doing is visual—you have to capture the world in a drawing."

Architecture is another subject that needs to be dealt with, especially in superhero comics, "For superhero comics, you should learn the skyscrapers of New York, and the buildings of Los Angeles. You need a thorough knowledge of every kind of architectural style, because you never know what you will be called on to draw."

Alcala's personal library includes books on fashions since the 1500s, military uniforms throughout history, and military vehicles of all kinds. Even if he doesn't have a specific need, he will still purchase a good reference book, because he never knows when it will come in handy. "In the Philippines, I had a lot of magazines, and I clipped out things that I might use. From Life magazines in the 40s I tore out the artists I liked. Of course, most of the magazine was about the War, and I would save the photos. If I saw a good truck, I would cut it out. I kept one magazine to use as an album, pasted in the pictures, and created my own reference library. I had one section on US Army trucks, one on Japanese trucks, and so on. When you do a war story, the vehicles and weapons must be correct."

Anatomy and Proportion

One way to learn anatomy is to go to the gym and simply watch people. As they work out, you'll see the various muscles groups in action. Or take your sketchbook to the beach and draw what you see. Once again, direct observation is essential. If you want to learn to draw animals, nothing beats the zoo.

As you watch people, Alcala says, pay special attention to the hands. "The fingers are the most difficult part of the body to draw, because they have so much expression. They can be angry or happy. If someone is angry, they make a fist. People point or try to grab. Hands can be asking for money, or appearing weak and helpless. The hand is more difficult than the face, because faces aren't always moving. The only things on the face that actually move are the eyes, eyebrows and mouth. The ears, the nose and the hairline don't move. But the hand twists and turns."

Luckily, the artist has a top notch hand model standing by. "Draw your own hand. It's the one that's always around." Alcala always recommends using an affordable but always available model to pose—yourself. " Look around inside your house, draw the folds of the clothes, the drapery."

As you observe, pay attention to how people reveal their emotions through their body posture. Being able to express different emotions through anatomy is one of the most important storytelling tools for an artist.

We've talked a great deal about observation and memorization. By putting them together you learn the sense of proportion that is crucial to proper anatomy.

"The standard Olympian style is seven heads high. Draw a figure of a man, and he should be seven heads high from the very top of the head to the floor. Joe Kubert used a more than Olympian scale, nine heads high, but the standard is seven."

It is through observation that you learn the proportions of the human body. "The upper arm is longer than the lower. The upper leg is longer than the lower leg. On the head, the eye lines up with the ear, and so on. In general, there should be the width of an eye between the eyes. There are also guidelines of movement. For instance, you cannot turn the head halfway to the back. You can almost do it, but it's not possible to turn it halfway. These are all proportions that the artist must learn."

Again, the only way to learn is by observation and getting a pencil out to practice. "You cannot just memorize everything that you see. You should practice just sketching. The more you doodle the more you remember."

Once you learn the correct proportions, you can apply them to situations that you haven't directly observed. For instance, take drawing from a bird's eye view or a worm's eye view, "It's like doing a drawing of a house and knowing the proportion of the sidings, plus the window. If a person was standing on the floor inside, you can see part of his body over the window, so you can imagine where the floor is.

You'll notice throughout the art examples in this book that Alcala tends to show the entire figure in a panel. Some artists will crop

out part of the figure, which is a valid technique, Alcala acknowledges, as long as it isn't used to hide a problem part of the anatomy! "Some people cheat. Look at Frank Frazetta. Every time he draws a full figure, there's a rock, some grass, or some other object in front of the feet!"

The young artist should work on every part of the anatomy, not just the part that he or she is good at. "I know lots of artists who are good at faces; they've practiced hundreds of faces and their expressions, but they never practice hands and feet. That's the wrong way to go about it. They thought that it was good practice to memorize a few things, but the best thing is to memorize the whole picture. Draw hands at many angles, draw the body at many angles."

Once again, the only way to draw people is to look at real people. "Don't idolize somebody in comics who doesn't know anatomy. There is one very famous artist who drew Tarzan. If Tarzan is just standing there, his chest muscles are well drawn. But when his arms are raised, the chest area looks exactly the same. I suspect he had a wooden model with arms that move—but this didn't show the muscles stretching, as they do in reality."

Of course, artists look at other artists and they fall in love with something in their idol's style. "It's a lot harder than it sounds to avoid simply following your idol. It's okay to idolize someone, but always follow nature. Nature is the best designer. If you find something you like, combine it with something from your idol. If you have five idols, only pick a little bit from each. You have to develop your own style.

That comes when you express things with your own feelings. If you pick up the way one artist draws landscapes, and some tricks of anatomy from another artist, after a while, these traits will disappear, and reappear as you, but only when you involve your own feelings.

"If you just idolize an artist, and completely trace his work and mimic him, then you can't get away and you've become the tail of you dog—you're always following. People tell me I have my own unique style. They don't know I picked things up from a hundred different artistic influences."

Composition

Composition is probably the most important element of drawing. A strong composition makes even commonplace material fascinating. Weak composition drains subjects of life and interest.

"The secret of strong composition is contrast," says Alcala. "There are several basic ideas on composition, for instance, the 'O', where you encircle the figure in the center, with foliage, for instance. Another kind of composition I use in panels is the 'L', a man is standing with his shadow extending from him;

one figure is the main figure, the other is secondary. This creates a contrast. A comic book panel can be laid out in a kind of 'X' or 'T' or even 'N'." Look at the panels below and see if you can see these basic compositions.

These are very basic compositions, but they provide a simple framework for a drawing. Avoid boring, symmetrical compositions. If, for instance, two people are having an argument in a panel, don't just show them standing at opposite sides of the panel. "It's always boring when you have one figure facing the other— two I's don't work! But if one figure

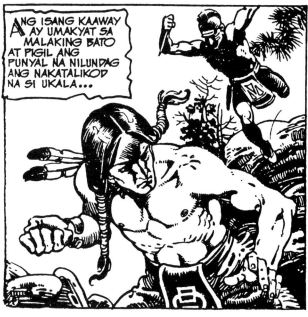
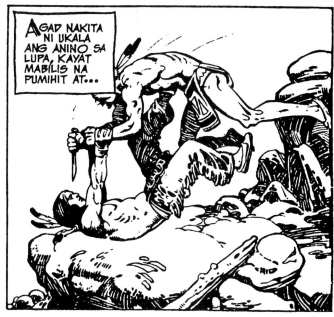

had his hands on his hips, and the other was gesturing, it's much more interesting.

"I call the "two I" composition amateur. Even if the drawing is absolutely flawless, it's amateurish because there's no contrast. The great artists became famous, not because they're good at anatomy, but because they were good at composition." Composition provides action, contrast, drama. It creates emotion.

As the above suggests, drawing exciting, dynamic comics is primarily a function of composition. Alcala has a very direct approach to capturing actions and emotions in his work: he

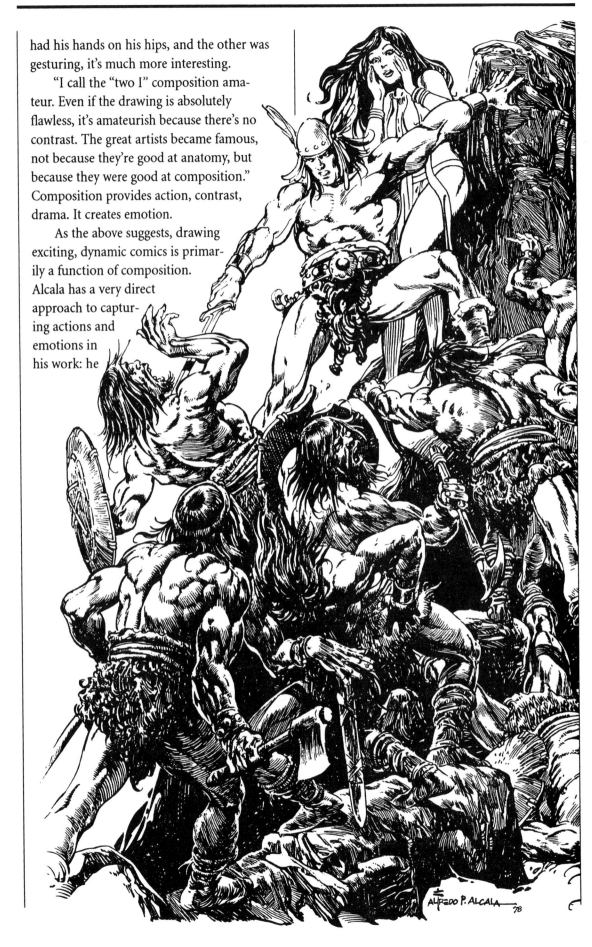

puts himself in the emotional frame of reference of whatever he is drawing.

"The most important part of action is experiencing it. The more you experience it, the more you know the action. I'm not saying that you should be out fighting, but as you draw, you should be experiencing it in your mind. Involve yourself in what you're drawing." When working on a drawing, Alcala doodles, trying many angles to see which has the most impact.

Light and shade are another problem which tend to perplex beginning artists. As always, observation is the key, Alcala stresses. "You can make your drawings lifelike if you observe how shadows really fall. If the light is from the left, then the right should be in shadow." It isn't necessary, however, to worry about every shadow that would occur in real life.

"A drawing isn't like a photograph. A photograph picks up everything. But in a drawing, you have a choice. Instead of the whole shadow on the face, you can only show what you feel you need to. In a photograph, sometimes the shadow hides important features, but in a drawing, you can show what is necessary on the face."

As in every aspect of art, there are no short cuts to learning about composition, light and shade. "Never take the easy way. The young artist must not short cut anything. Most young artists ask me what kind of brush I use. Then they go out and buy the same brush, or, if they have more money, they buy an even better brush. Their tendency is to think that if they have better materials, they're better than me. But they don't realize, of course, that it's you, it's not the brush, not the pen, not the pencil. Don't be bothered by what kind of pen you use—just make sure it works and you use it!"

"So many people think there's a short cut. They say, 'I want to be like you.' I say 'I'm in my 60s, you're only in your 20s—do you want to add 40 more years to your life?' You just have to work hard. There isn't any substitute."

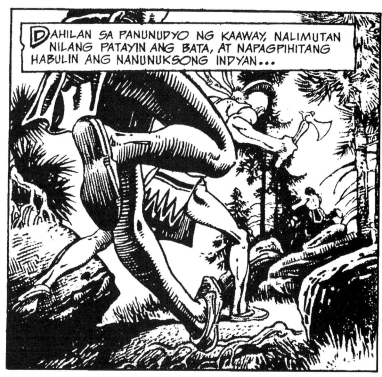

THE LIGHT *PULSED* AND *DANCED DAZZINGLY,* DRAGGING THE SLAVE FROM HIS DEATH-LIKE *TORPOR!*

BY THE GODS! WHAT *IS* IT?

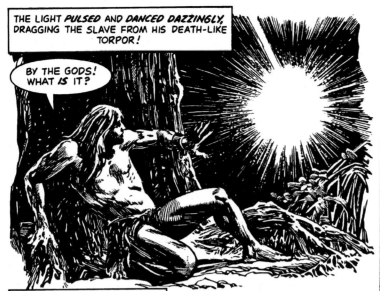

CAUTIOUSLY, HE *ADVANCED,* HIS HEART POUNDING.

IT... IT CAN'T *BE!* A *SWORD* CASTS SUCH A GLOW?

A *SWORD! YES!* IT WAS JUST WHAT THE SLAVE *NEEDED...*TO *SLAY* HIS ENEMIES SHOULD THEY AGAIN *COME* FOR HIM!

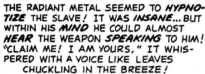

THE RADIANT METAL SEEMED TO *HYPNOTIZE* THE SLAVE! IT WAS *INSANE...* BUT WITHIN HIS *MIND* HE COULD ALMOST *HEAR* THE WEAPON *SPEAKING* TO HIM! "CLAIM ME! I AM YOURS," IT WHISPERED WITH A VOICE LIKE LEAVES CHUCKLING IN THE BREEZE!

YET, ONCE THE GLISTENING STEEL WAS WITHIN HIS GRASP, THE *HATRED,* CAREFULLY CULTIVATED BY YEARS OF *ENSLAVEMENT... MISTREATMENT...* HAD *VANISHED!*

A MYSTERIOUS *CALM* SETTLED UPON THE MAN! IT WAS AS THOUGH HIS *SOUL,* FOR THE FIRST TIME...HAD FOUND *PEACE!*

AND MORE...HE KNEW IT WAS BECAUSE OF THE *SWORD!* THE SWORD WHICH *CARRESSED* HIS INNER EAR WITH GENTLE WORDS WHICH GUIDED HIM *DEEPER* INTO THE MYSTERIOUS *FOREST...*

...WHICH GUIDED HIM TO A SMALL *RUDE HUT* NESTLED SNUGLY AMONGST THE TALL WINTER OAKS!

WHAT *SORCERY* IS *THIS?* HOW IS IT THAT A *SWORD SPEAKS* TO ME?

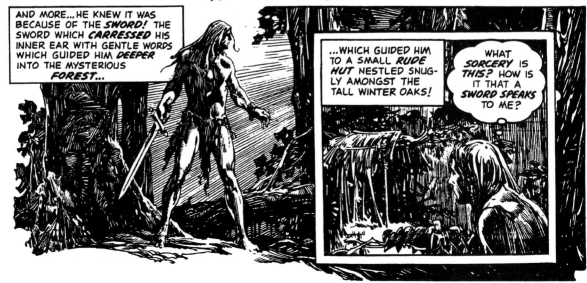

Thinking About Comics

Most of the preceding comments apply to any kind of drawing, but to be a good comic book artist requires much more than good draftsmanship. A comic book artist is also a storyteller, and must be able to think dramatically and logically. The comics artist will also be called on to create vivid characters and portray a wide spectrum of emotions. Once again, Alcala has a time-tested approach.

Though as a child he loved to draw anything, Alcala's dream was to work in American comics. In order to make this dream a reality, he studied the market. "I collected American comic books, and noticed what they were putting out. Over a period of time I switched my drawing style from the Filipino style to the American style. I didn't do it abruptly, so people might say 'Hey, you changed your style.'

"I told my friends that within five years I'd be doing some work in American comics. I had just created Voltar, and everyone was confused. 'Hey, Alfredo, what are you doing with Voltar? You cannot turn that into a movie.' I told them I hadn't created it for the movies; I had just created the story to make myself happy. But I said remember, 'in five years you will see this in American comics.'

"They laughed at me. 'Alfredo, you need some sleep!' But my prediction came true."

Later on, Alcala made another bold claim about applying his Voltar-style rendering to the American character Conan. The reaction was equally disbelieving.

"People thought I was dreaming. But five years later, I received a Conan sample of John Buscema's to ink."

Alcala was drawn to the world of comics because of the wide variety of material he could work on. "I like everything: superheroes, adventure, fantasy, fairy tales, horror, historical, or war stories. I wanted to draw comics to show the world I could do historical material, but I also wanted to draw sword and sorcery.

"I like fantasy, but I also like to work in a more cartoony style." The key to caricature is exaggeration. "You exaggerate the reality. You

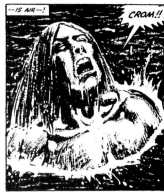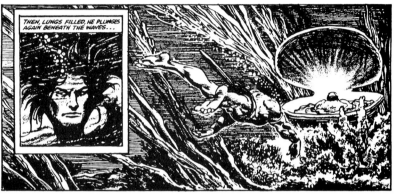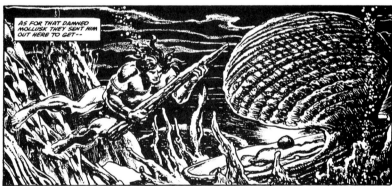

make everything larger. If you are portraying an idiot, you make the neck longer, and make the eyes a little closer together. You can have more exaggerated action in cartoony material than you can in realistic material."

When Alcala gets a script, he has a procedure that he has developed in order to approach the material. "I read the script twice before I begin to draw it. First I read it quickly to get an overview of the material. Then I read it slowly, with a pad and pencil at hand. As I read it, I make stick drawings on the pad.

"Then I note the panels. For instance, in panel 3, I'll get an idea of how to show the characters. For each sequence I do a doodle or a breakdown, getting the expression or what-

ever the action is. But I've gotten a sense of the story from the first quick reading.

"The action is the first thing I think of. In comics you should imagine the action right away, especially the characters who will be in action. But you also must remember what you learned in a portrait or a life drawing class."

As he reads the story, Alcala acts it out in his mind, imagining himself in the situations. "If it's a Conan story, I pretend to be Conan. If you're doing a story about a stand-up comic, you pretend to be a comedian. Whether it's a millionaire or a miser, act it out in your mind. When you're a comic artist, you're the actor and the director.

"Always imagine yourself in the situations you're drawing. This helps to give you the expressions and body language that make vivid comics. The artist shouldn't just be a viewer—he should be involved in the action."

The next stage for Alcala is what is often called the thumbnail breakdown. "When I look at my pad it's full of doodles. I need to make a clear drawing of it, even though it's still rough. I decide which panels are the most important and which need to be bigger or smaller. A thumbnail is a sketch drawing, with a circle for a head and a square for the body." Many artists like to do the entire page in thumbnail form, but Alcala prefers to do it one panel at a time. This is because he has trained himself to think of the page as a whole. One of the things he is

watching out for at this point is avoiding monotony in the panel layout.

For instance, "you shouldn't always put the character in the center of the panel. Sometimes it's better to put him on one side. Avoid always making a drawing in the center, because it will turn out to be monotonous." Another kind of monotony comes from when an artist may change the angle from which a figure is viewed without changing the size of the figure.

"I call that 'force of habit.' Every time the artist roughs in the figure, it's always identical in shape. So when he does the final pencils, they're all the same size. To avoid this you should make sure that once in a while you vary the size of the rough. Make a big circle, or small, or make it a 3/4 angle instead of a front view."

At this point in the process, Alcala is trying to think of the most dynamic way to tell the story. Many artists think of the comics page as being a nine panel grid, but Alcala prefers the six panel grid because he feels too many panels lead to confusion on the part of the reader.

He also plays around with telling the story from different angles. "Up shot, down shot, close-up, side view, back view—keep changing. You're the director, you're looking in the camera and saying, here I should do a back view, or here I want the camera to be at a dramatic angle."

Potential comics artists should be aware that there are two commonly used methods of collaboration between writer and artist.

In the full script method, the artist is sent just that, a full script, complete with panel descriptions and all the dialogue that will go into each panel. In the breakdown method, the writer prepares a synopsis of the story, which the artist then lays out as he or she sees fit. Although this method would seem to give greater latitude to the artist, it is not without its pitfalls.

"The breakdown method can be quite a challenge for a beginning artist. You have to learn how to squash or stretch the story." By "squashing" and "stretching" Alcala means the way in which the story is paced. Sometimes an artist will get carried away with drawing big, exciting panels, and forget that one important story point has yet to be drawn. "When you squash you may forget that something's missing. Instead of doing it in six pages you have four and after you've squashed it all together, you often find you have something left out."

In general, he prefers to work full script for this very reason. "In a synopsis style, you have to know how many panels each action will have. In a script, you already know how many panels you'll need.

"A full page might be a splash panel and three panels. When you have a panel that's less important, don't be afraid to do it as an inset panel. Sometimes you put the whole figure in the background, and the next time in a small inset panel. It doesn't become monotonous. When something is clearly more important, make a bigger panel and instead of cutting it in the middle, use an inset panel." Other forms Alcala uses to break up

the storytelling are silhouette panels, and panels with special added borders.

He gives this as an example of monotonous storytelling: "'First panel: What's your name? Second panel: My name is Pedro. Third panel: Oh, where do you live?' and on and on. You could have put this all into one panel! Don't do it in so many panels. That's where I play with the pacing."

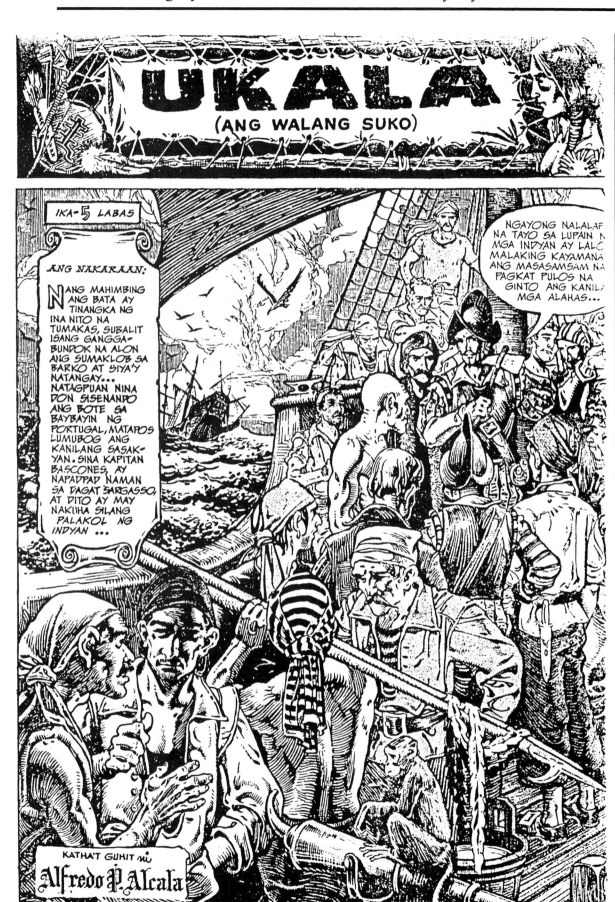

Ukala

Alcala's first big hit in the Philippines was the strip, *Ukala*, which was later made into a film. Inspired by various sources, including Longfellow's epic poem Hiawatha, and films about Native Americans, Alcala created an epic saga that included sea adventure, romance and daring escapes.

"Ukala was the first comic strip in the Phillipines about Native Americans, and it was an immediate sensation." Alcala adopted a new drawing style for the book, as well, a more decorative, densely inked style which surprised everyone and proved very influential. "Artists were all surprised to see the details in the backgrounds, and the rendering on the anatomy. When I started I wanted to do something influenced more by Brangwyn and Cornwell than other comics artists."

For the story, Alcala wrote about the things that interested him. "I was very interested in ships of the period, so I put in a journey across the Atlantic. I also wanted to put in the Sargasso Sea, and a romance between Ukala, a Native American, and a Spanish girl."

Alcala still considers Ukala one of his finest achievements in story and art. The movie adaptation was as popular as the comic strip, it was quite a feat to have a movie made from his work at the age of 27.

"There were other movies made from things I'd worked on, but they weren't my creation, since most stories I illustrate are from other writers. But Ukala is the one I created myself."

The artwork on this page typifies the tremendous amount of detail and research that Alcala devoted to the Ukala saga. This particular page illustrates just how much information can be given to the reader in one pleasing layout. The full figures in the center of the page give the composition a sense of drama, pulling the reader into the page. Each smaller illustration gives the viewer an immediate sense of the action. The text works in total harmony with the art.

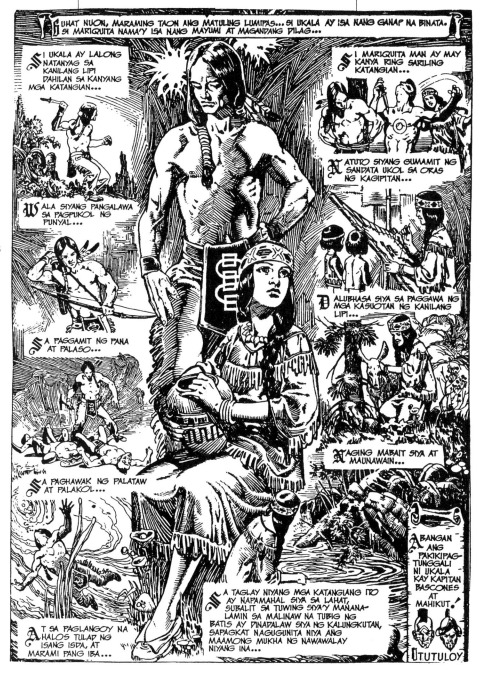

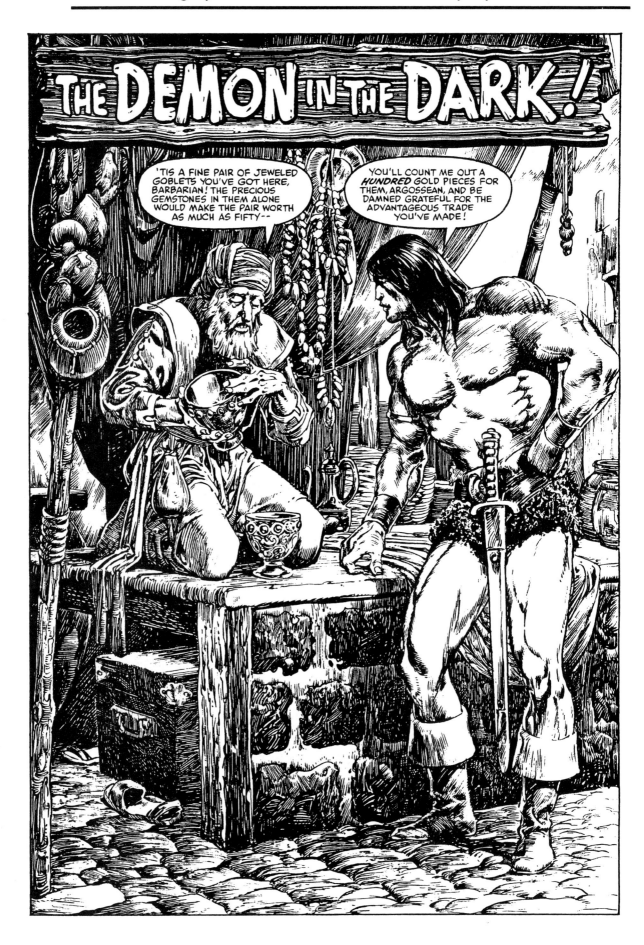

Conan

By the early 70's, many Filipino artists had started working on American comics as inkers. Alcala was called in to work over John Buscema's pencils on *Conan*. Based on Robert E. Howard's barbarian sword & sorcery character, the comic soon gained a devoted following.

Alcala had already read Conan's original adventures in pulps from before World War II. "I remember Conan during the Japanese days, when I was buying pulp magazines. There were lots of adventure pulps - *Argosy*, *Doc Savage,* and so on. Then I happened to talk to the owner of the stand, who gave me some new ones to read. I went home that night to read this new stuff, and it turned out to be Conan. I thought it was a good story."

Much later, Conan would be adapted to the comics for the first time with stories by Roy Thomas and art by Barry Smith. The first issue of the black and white version of Conan, *Savage Sword of Conan*, made its way to the Philippines, where, as previously mentioned, Alcala told his friends that someday he would be working on Conan. They found the idea unlikely. At this point, Alcala was in touch with Marvel about doing some horror material. "Suddenly, Roy Thomas sent me some of John Buscema's Conan pages. Wow! It was almost as if I'd had mental telepathy."

Barry Smith's Conan had worn a short skirt, which Alcala felt was less than swashbuckling. So Alcala took the liberty of changing Buscema's pencils and adding the furry garb that he wears to this day. Voltar had been wearing this same type of outfit nearly 10 years previously. In fact, Alcala had already developed many of the conventions of the sword and sorcery genre in

comics with Voltar. Conan had larger muscles and a smaller nose, but both Voltar and Conan had a tendency to fight mythical beasts and find beautiful women.

The page below illustrates how few words are needed to express mood and action in a comic book story. These black and white Conan stories gave Alcala a chance to recreate the masterpieces in inking that he had perfected with Voltar in the Philippines.

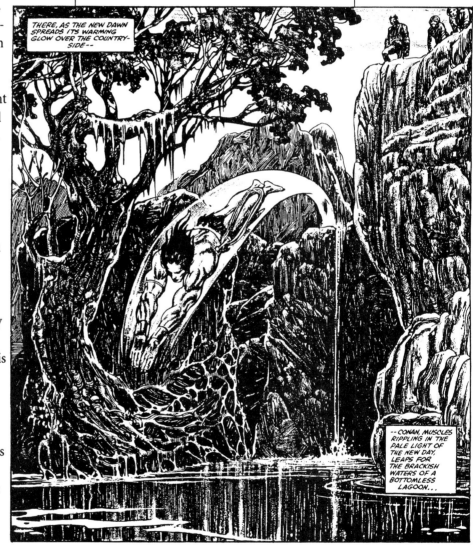

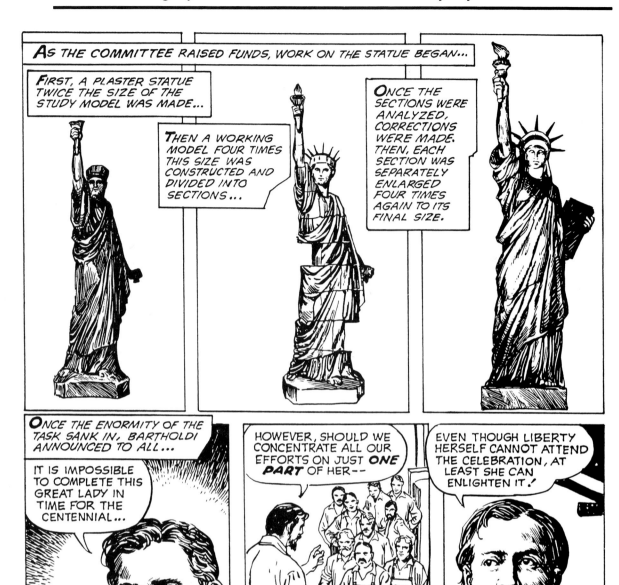

AS THE COMMITTEE RAISED FUNDS, WORK ON THE STATUE BEGAN...

FIRST, A PLASTER STATUE TWICE THE SIZE OF THE STUDY MODEL WAS MADE...

THEN A WORKING MODEL FOUR TIMES THIS SIZE WAS CONSTRUCTED AND DIVIDED INTO SECTIONS...

ONCE THE SECTIONS WERE ANALYZED, CORRECTIONS WERE MADE. THEN, EACH SECTION WAS SEPARATELY ENLARGED FOUR TIMES AGAIN TO ITS FINAL SIZE.

ONCE THE ENORMITY OF THE TASK SANK IN, BARTHOLDI ANNOUNCED TO ALL...

IT IS IMPOSSIBLE TO COMPLETE THIS GREAT LADY IN TIME FOR THE CENTENNIAL...

HOWEVER, SHOULD WE CONCENTRATE ALL OUR EFFORTS ON JUST **ONE** PART OF HER--

EVEN THOUGH LIBERTY HERSELF CANNOT ATTEND THE CELEBRATION, AT LEAST SHE CAN ENLIGHTEN IT!

ONLY WHEN A SECTION HAD BEEN PERFECTED IN PLASTER COULD A WOODEN MOLD BE MADE TO FIT ITS COPPER SKIN. EACH SECTION REQUIRED ABOUT 9,000 MEASUREMENTS! BARTHOLDI CHECKED EVERY DETAIL.

The Gift

In 1986, Alcala collaborated with poet/actor Henry Gibson on a graphic novel to commemorate the 100th anniversary of the Statue of Liberty. Originally, it was to be a corporate-sponsored book in full color, but when the funding fell through, Blackthorne Publishing agreed to publish it in black and white. Alcala points out that he had originally planned the book for color. "You'll notice that my drawings are very simple—the sky is pure white and so on. That's because when properly colored, it was supposed to be like a painting."

The Gift is an example of a very research-intensive project. The costumes and scenes needed to be accurate.

"Henry Gibson helped a great deal with the research. He would go to the library. I would tell him what I needed, and he'd do a lot of searching. We had another researcher who went to France and visited the house where Auguste Bartholdi [who designed the Statue of Liberty] lived. It's like a museum now, very well preserved, so he took pictures of it for me.

"The more I can do to make something real, the better, but there are problems with using photos. With Bartholdi's house, there are no other old buildings around, instead there are new hotels nearby. I had one photo where part of the roof was covered by part of a newer building, so I had to continue the roof in the same old-fashioned style."

Alcala also used actual photos of Bartholdi and his wife, but once again, he had to improvise a bit. "Sometimes the shots were only from the waist up, so I would look at the skirt from another photo, and use that."

When doing a historical story, the artist should try to project himself back to the time. "Remember, you can't make it look modern in any way. Let's say it's 1890. In 1890 there are no airplanes, no television, no elevators, people wore their hair in a certain style. This is where reference really helps."

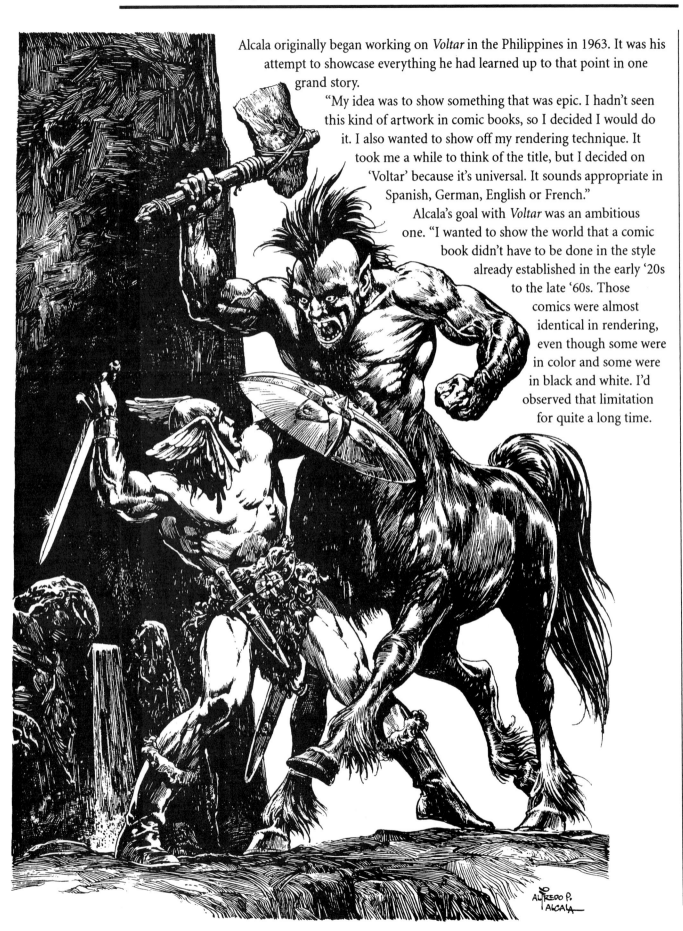

Alcala originally began working on *Voltar* in the Philippines in 1963. It was his attempt to showcase everything he had learned up to that point in one grand story.

"My idea was to show something that was epic. I hadn't seen this kind of artwork in comic books, so I decided I would do it. I also wanted to show off my rendering technique. It took me a while to think of the title, but I decided on 'Voltar' because it's universal. It sounds appropriate in Spanish, German, English or French."

Alcala's goal with *Voltar* was an ambitious one. "I wanted to show the world that a comic book didn't have to be done in the style already established in the early '20s to the late '60s. Those comics were almost identical in rendering, even though some were in color and some were in black and white. I'd observed that limitation for quite a long time.

That's where I said to myself, if I do a black and white illustration for a comic book, I will apply this other technique just to show the reading public that there's not only one style in comics—that I can put in another one."

The intense rendering technique that Alcala used for the first time gained the strip a great deal of attention. "I had been practicing this technique in my spare time. When I finished with my regular comic book pages, I'd practice drawing landscapes, walls, rocks, trees. I thought it would be interesting to do a whole story using this. Little by little, I developed a character. Then I decided to make a story using some of the ideas I'd picked up during my reading."

Although today's readers will see a resemblance to Robert E. Howard's Conan, that was not Alcala's inspiration. "For a long time I had wanted to do a story that showed off the human figure. I wanted to draw jungles and forests. I couldn't use them in ordinary comics stories."

"During the Japanese occupation, there were pulp magazines for sale all over the place. I read Conan but I was confused by the story. I thought Conan was this sword and sorcery character, but lots of the plots involved magic. To me, magic always makes me think of the Arabian Nights, flying carpets and the like. Without the 'barbarian' element, however, Conan was more like a book about King Arthur. So reading Howard, I was confused by the shaping of the story and how it ended. They always confused me, so I decided not to read them any more! I like more of a mystery, like the tales of Sherlock Holmes and others, but also mysterious enchanted forests, secret caves... I like that sense of magic involved, as well. *Voltar* is where I embodied all of these ideas."

Alcala cautions the reader not to be too caught up in the rendering style, as impressive as it may be. "It's a very important point: even though the rendering is very striking, if you took it all away, you would still see very solid composition." As we have mentioned through-out this book, the composition is always the structural skeleton beneath the rendering.

"As you look at the pages, you'll see that I used five tones: solid black, solid white, and three grays, heavy gray, medium gray and light gray. I consider white as a tone. You'll notice in every style of rendering, I always use those five tones, so I can give it more of a three dimensional effect. If you were to look at a page from a bit of a distance, you almost wouldn't see the lines, you'd just see tones, like a wash. But up close, you can see it wasn't a wash at all."

This technique also gives the strip a sense of contrast, mass and solidity which helps to give this wildly fantastic world of sorcery and adventures a sense of realism.

Voltar created a sensation in the Philippines and was Alcala's greatest triumph yet. The artistic style was revolutionary, and Alcala won the top prize in the Society of Philippine Artists and Cartoonists for six years running.

"When I did *Voltar* in 1963, I influenced everything in comics, because of the sudden big change in my technique. Because of its success, there were soon lots of people trying to imitate my style. People said the style wasn't Philipinized. I said, 'No, it's international. I think this will be published in America.' They thought I was crazy and that I was dreaming. Of course, it was a dream, but I had a feeling that it would come true."

In fact, it did. In 1977, Bud Plant, one of the founding fathers of the independent comics movement, published *Magic Carpet #1*, featuring a brand new 30 page Voltar story. With a script by Manuel Auad, this was one of Alcala's greatest visual tour de forces ever. Eventually, *Voltar* was published by Warren comics, with scripts by Bill DuBay.

Today, Bud Plant runs a wonderful mail order book company specializing in comic books as well as fine art books on illustrators and painters. Please write to them about any copies of work by Alfredo Alcala and other illustrators. Art students, teachers and educational institutions should identify themselves

as well. Write to: *Bud Plant Comic Art*, P.O. Box 1689, Grass Valley, California 95945 or call (916) 273-2166.

In the following pages, Alfredo Alcala will take us step by step through the thought process behind this Voltar story, unseen for nearly 20 years. As you will see, his idea on each and every page is to make it different from every other. This is a monumental challenge to the artist's imagination, but it is one that Alcala is more than ready to meet.

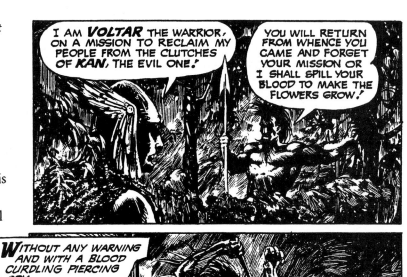

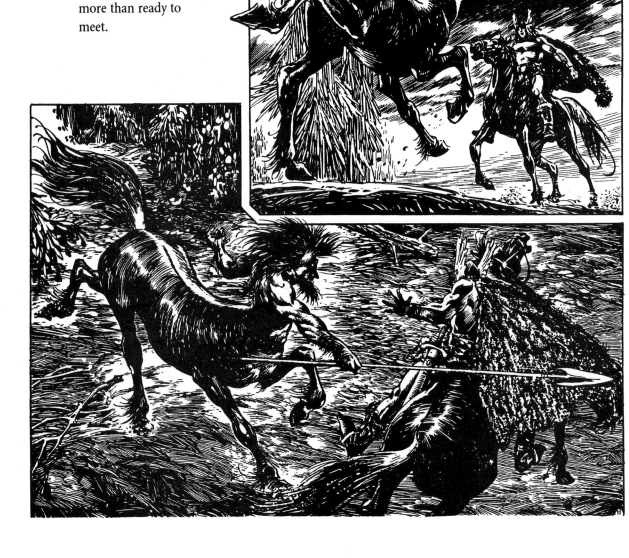

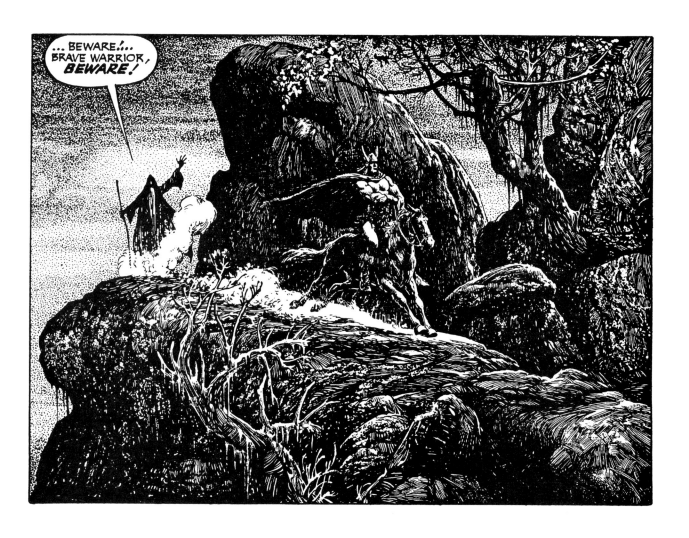

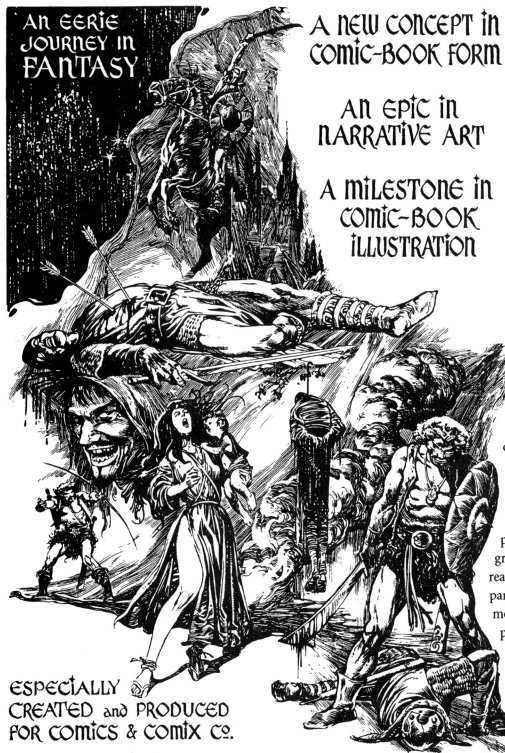

AN EERIE
JOURNEY IN
FANTASY

A NEW CONCEPT IN
COMIC-BOOK FORM

AN EPIC IN
NARRATIVE ART

A MILESTONE IN
COMIC-BOOK
ILLUSTRATION

ESPECIALLY
CREATED and PRODUCED
FOR COMICS & COMIX Cᵒ.

I'm trying to capture the imagination of the reader with all the images, but it's also a problem of composition and design. The lettering must be balanced with the drawing. When you're designing this kind of page you need to make sure that the text will fit in the space, and that it's legible.

The man shot by arrows creates a strong horizontal element on the page. I made sure that there are lines that cross against him, so you cannot see a straight line like a horizontal. The reader's eyes go around the page, instead of going right to the center. That way, the reader follows the progression of images. It's another form of storytelling.

FOLLOWING PAGE ➤

Normally, I prefer to use no more than six panels on a page, but here I used a 12-panel grid. The small panels draw the reader into the story. The first panel sets the stage, showing the moon and castle, and the dripping leaves on the tree give the sense of mystery for what is to follow. The moon, already established, ties in the second panel, and appears darker in the fourth panel, which also establishes the wind. Every panel builds on the previous one to establish a new facet of the scene. In the final panel, we see three different sizes of running figures. Showing only the feet at the right gives a sense of urgency and action to the drawing.

The problem here is to make the composition balanced, with light and shade. It's like a teaser. When you open the cover, you're introduced to the style of drawing, and you also see the elements that will be in the story: the characters, the man on the horse, the man with the sword, and the death of a character.

THE CLOAK OF NIGHT ENGULFS THE TOWER OF ZIMAR. A THIN VEIL OF FOG, LIKE A BLANKET OF SLEEP, SILENTLY SLITHERS FROM THE HILLS AND COVERS THE TOWN BELOW. A BELL RINGS THE HOUR OF MIDNIGHT, AS A HUGE MOON FREES ITSELF FROM THE TREE TOPS AND SHINES AN EERIE GLOW ON THE CASTLE.

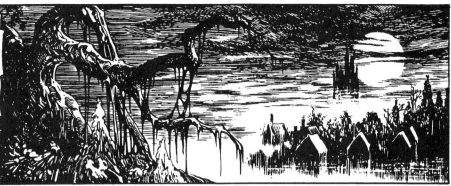

THE EERIE SILENCE IS SOMETIMES BROKEN BY THE SOUND OF WINGS FLUTTERING IN THE DARKNESS OR OF A WOLF HOWLING...

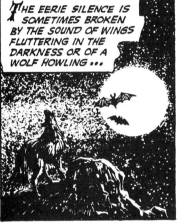

THE DARKNESS BRINGS VISIONS OF NIGHTMARES IN THE DARK CORRIDORS OF WEAK MEN. THEY ARE THE PREY OF FORMLESS SHADOWS THAT LURK BEHIND A PILLAR, A CORNER, A DOOR.

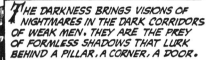
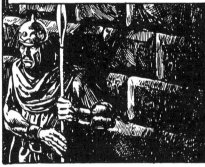
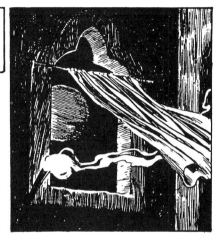

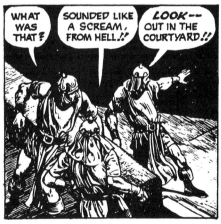

WHAT WAS THAT?

SOUNDED LIKE A SCREAM, FROM HELL!!

LOOK-- OUT IN THE COURTYARD!!

ONCE FEAR CHOKES THE HEART---

--THE MAN IS DEAD!

YAAAAAAA

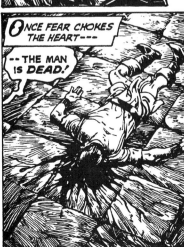

This is the real event. The size of the drawing throws you right into the middle of the action. I show the drawbridge, the gate, the walls, and those people attacking the castle. It's a very complicated composition, but I was very careful not to have anybody in the same position. The man on the left half has his sword raised at one angle, the man on the right has it held horizontally. You should always avoid showing the same action and have figures in different positions to keep it moving. Otherwise it will come out like cadets marching in formation! On this spread, even the dead people have different positions. One has his head hanging, and the other has his leg down. The only thing that's the same is the wall.

Always keep in mind that the eye goes to the area of greatest contrast in a drawing. I put in three fires in order to have white areas, but it is also part of the story. With this white background, especially the one that's almost in the center of the page, you can see more of the figure against it. On the right half, you can see the ax, spear and helmet against the white area. Because it's nighttime, there's a great deal of darkness, but that doesn't mean it all has to be dark. There must be visual contrast at all times, which means you should not be locked into following the reality of things too closely. Of course, at nighttime when there's no moon, everything would really be dark, but you are trying to dramatize things, and you have to think dramatically. I made it a little darker than ordinary to show that it's night, but I put

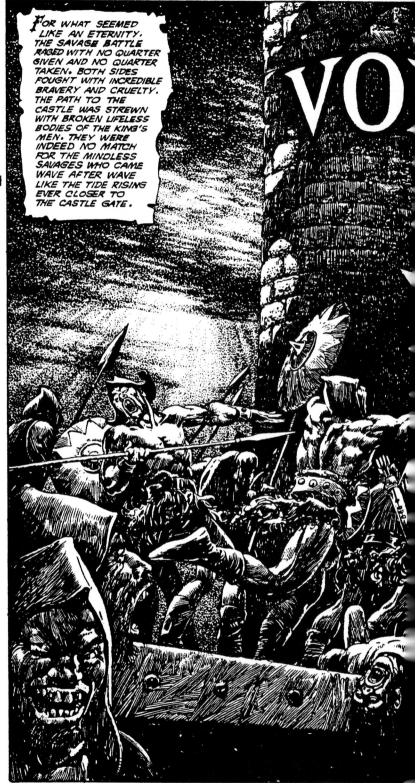

FOR WHAT SEEMED LIKE AN ETERNITY, THE SAVAGE BATTLE RAGED WITH NO QUARTER GIVEN AND NO QUARTER TAKEN. BOTH SIDES FOUGHT WITH INCREDIBLE BRAVERY AND CRUELTY. THE PATH TO THE CASTLE WAS STREWN WITH BROKEN LIFELESS BODIES OF THE KING'S MEN. THEY WERE INDEED NO MATCH FOR THE MINDLESS SAVAGES WHO CAME WAVE AFTER WAVE LIKE THE TIDE RISING EVER CLOSER TO THE CASTLE GATE.

in a white area to balance the dark.

These pages were rendered with a combination of a Chinese brush and a pen. If it's a straight line, I used a pen, but if it doesn't run in a straight line, then I used a brush. I used

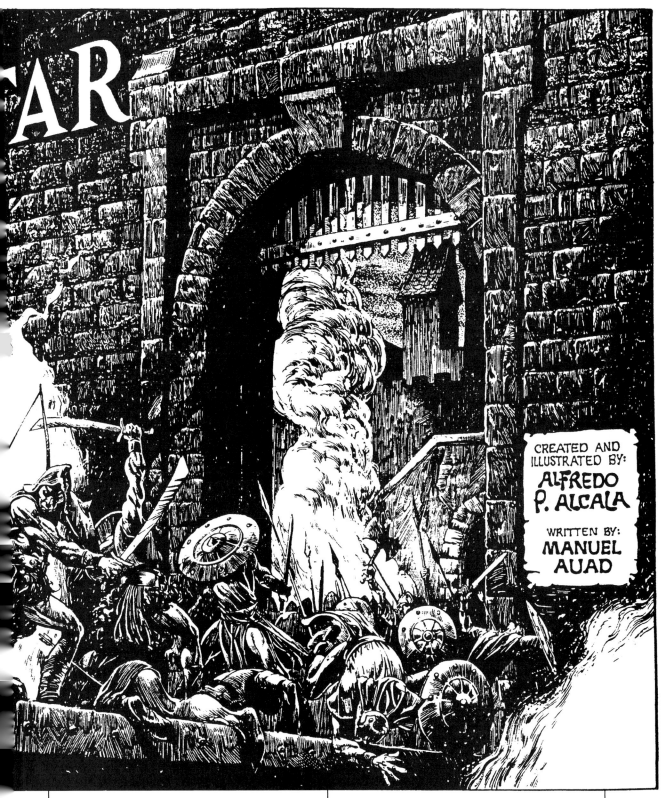

CREATED AND
ILLUSTRATED BY:
**ALFREDO
P. ALCALA**

WRITTEN BY:
**MANUEL
AUAD**

both because if you always use a pen, the pictures become stiff. A brush can make it more graceful, but by the same token if you always use the brush, everything will have that quality - the wall will become graceful, or a cabinet or a table. It would be appropriate to use a stiff line for these kinds of objects, but you must be careful where you use it.

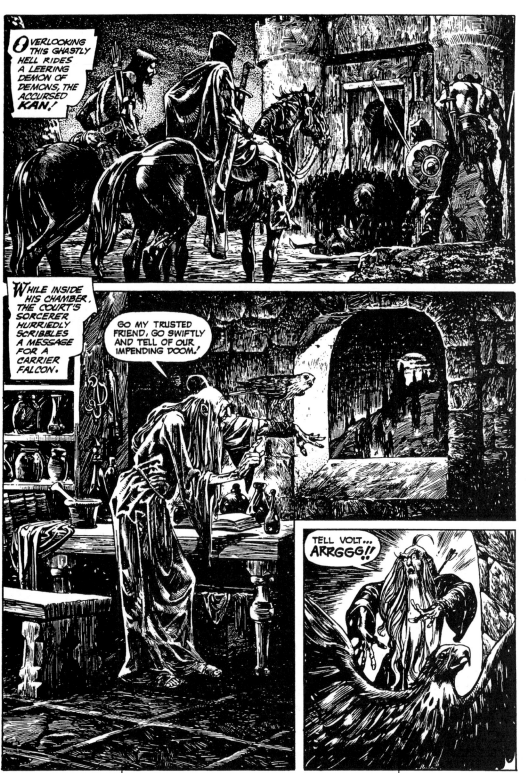

cartoony, the more you get the expression of the character. I put in several things to make him stand out, like the hair standing up on his head. That makes him an "eye-catcher". He's interesting, so I feel he's a good character. He doesn't look modern, or even 300 years old. He could have been done 1000 years ago.

This is a good example of drapery. The trick of drapery is gravity. Remember, gravity is always there and it is always at work. The sleeve is hanging down, but I made a contrast line of the folds to make it more exciting. In reality you will not always see those, it will be almost flat, because it's being pulled by the gravity, but here I didn't follow this too closely. Remember, you want to make something that will catch somebody's eye.

The old man is also an eye-catcher because he's the only curved object in the panel. He's also an example of something I tried to do on all the pages. It's a decorative feeling, something that's striking to the eye.

FOLLOWING PAGE ➤

This page is a good example of the five tones, from the white clouds to the black hawk. The first panel is a landscape, which I wanted to make as interesting as possible.

The figure of the old man here is perhaps my favorite figure in the story. I was very pleased with how his clothes, the folds of his clothes, and the rest of the composition combined. He looks very old - it's a bit cartoony, but to a certain extent, the more you make it

Since this story is set in a mythical past, it's important for the landscape to be realistic, although there is still the decorative style I spoke of earlier. If you look at my forest, trees, rocks and so on, it doesn't look like a common garden. It has a old, wild look. Nobody planted a tree, nobody landscaped the mountain, nobody cleaned the area.

People have asked me if I was influenced by printmakers like Gustave Doré. As I keep saying, you learn by observation, and that includes looking at other artists. I noticed that this kind of technique, such as Doré and others used, gives a three-dimensional effect. But their style is engineered so that everything is smooth and graceful. That's not the way I went. I use a heavy line, a fine line, a square corner or even rough lines. If you look closely, you'll see it's not graceful, it's rugged and pointed. Even the leaves of the trees are rendered so that you could believe they existed long ago. It's only make believe.

Turning to the figures, they are back to back, but in completely different positions. This was a very difficult composition. I could have had the

man and the boy looking the same way, but there would have been no contrast. So I twisted it so it's much more interesting. Just showing the bird flying and the boy holding a bow and arrow is simple, but if you indulge in a more interesting composition, it turns out that everything is important—the birds, the trees, the mountain, the cloud, the figures. There's

interest throughout the composition. Sometimes I don't see the background as "just" background. Rather, the background is part of the characters, in a way. But it's much more interesting this way, when I take the trouble to fully render the tones.

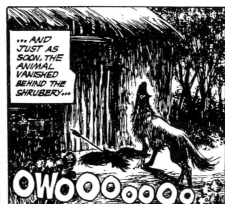

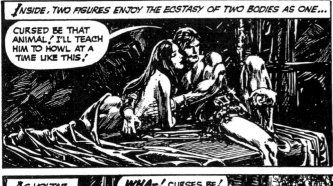

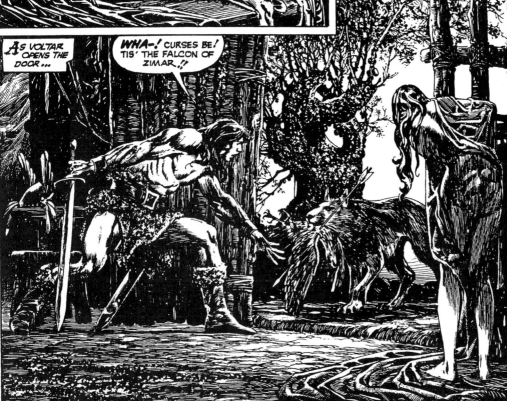

ground in to show the woman's head. The man is on a darker background, so I put in more white highlights in his hair and muscles, so you can see the contrast.

The tree is a new texture. I like very old trees. I've seen them in the Philippines. I always love a unique tree—I don't want to look at just a simple tree, like a pine tree standing straight upwards with the branches hanging straight. Instead I want the branches to be leaning more horizontal, or twisting—whatever makes it more wild looking. But once in a while I must insert a simple tree just to contrast these.

FOLLOWING PAGE >

This page is very economical with white space. I wanted it to be more mysterious. In panel 2, the woman's leg is a white area, but her body is hidden in gray shadows. The body next to the horse is white, so you look at that. In the close-up, the woman's profile is white, and some of Voltar is also highlighted. Notice that it's more three-dimensional than the tree. The tree against the white sky is more like a paper cutout, but the figures are more rounded, because I used the tones.

I made the last panel rounded just to break from the monotony of the square right-angled panels. In the second to last panel, it doesn't

This is the first page where we see the hero—Voltar. You also have the supporting characters, the dog and the woman standing by the door. I put them in action, not just standing. The composition points to the dog, because it's in the center. I put a white back-

matter if I show more of the woman or Voltar. If I had made it a straight line, it would have been just the same old thing; so I put in a curved line.

The last panel has another example of an eye-catcher. There's a tree, a cabin, and Voltar waving good-bye— it's a panoramic view. This view also broke up the page so it isn't monotonous. Panel 1 is a close-up, standing. Panel 2 is a semi-close-up, medium shot. Panel 3 is almost a close-up, and now the last panel is a full shot. In a full shot I include a cloud, a tree, the dust, the ground, the leaves, the cottage and whatever else is there. There's no repetition of viewpoint on the entire page.

Even though I design one panel at a time, I've made a habit of not repeating the same panels on a page. Also, I don't ink from left to right. On this page, I inked the last panel first, because it was so interesting, and bigger. When I finished inking the bottom panel, I could get away from just that technique. I used a white background here, but I didn't use this technique every time. I already knew that I used it there, so I won't use it elsewhere on the page. If I use a white background in every panel, it becomes an ordinary drawing, an ordinary page, an ordinary comic. I want everything, every panel to be interesting in some way.

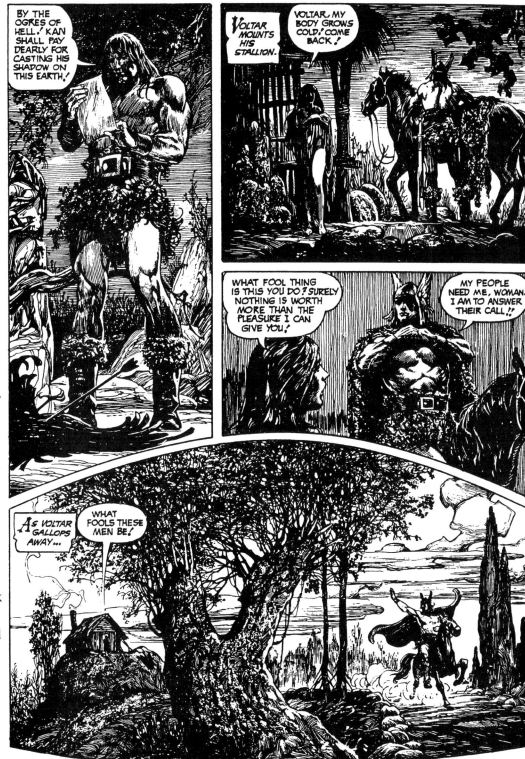

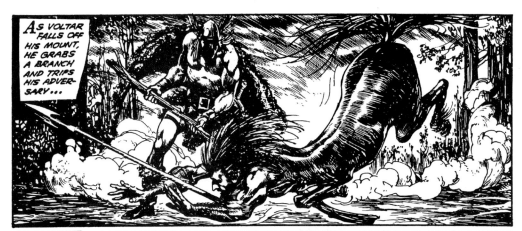

As Voltar falls off his mount, he grabs a branch and trips his adversary...

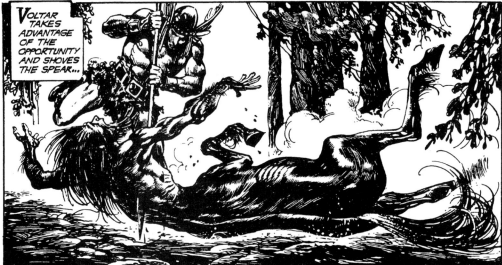

Voltar takes advantage of the opportunity and shoves the spear...

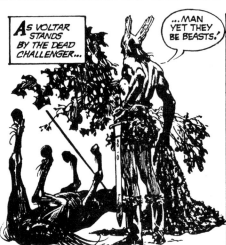

As Voltar stands by the dead challenger...

"...Man yet they be beasts!"

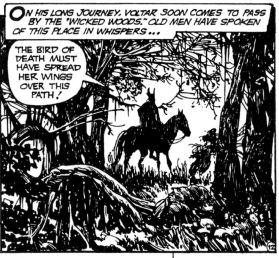

On his long journey, Voltar soon comes to pass by the "Wicked Woods." Old men have spoken of this place in whispers...

The bird of death must have spread her wings over this path!

with a brilliant look, so that's where I applied the white. I made the background totally white, but I put a lot of trees and leaves in almost as a silhouette.

Obviously, the centaur wasn't drawn from direct observation! What I did was to go a step further to make such an icon more believable. Notice the long, ungroomed hair. These creatures are wild, living somewhere out in the forest or the mountains, so I did the best I could to make it more savage and far away from any domesticated environment. That's why I exaggerated the hair and muscles.

In the second panel, the centaur is lifting his arm upwards when he was struck by the spear. From the elbow, the arm is very exaggerated, and the spear is part of the upper arm. I didn't do this to be realistic. I exaggerate to get your attention. My concern is not to make the drawing like a statue, or a human model. A human should be naturalistic, without exaggeration, but here it works to make the creature more fantastic.

FOLLOWING PAGE ➤

Here's an example of a page with a lot of action, and you must change your rendering style accordingly. You must be careful that you don't destroy the action with your rendering. To make the action more direct, I'll use a more solid black or white. I put in white clouds of dust. The body of the centaur appears shiny,

Yet another kind of page—this time there's a very leafy, floral look, and a different imaginary creature. The exaggeration is there in the figure of the satyr in the arm, the body, his back, even his fingers. I emphasize his profile and his pointed ears to make him stranger, but I also expand the muscles and the bone con-

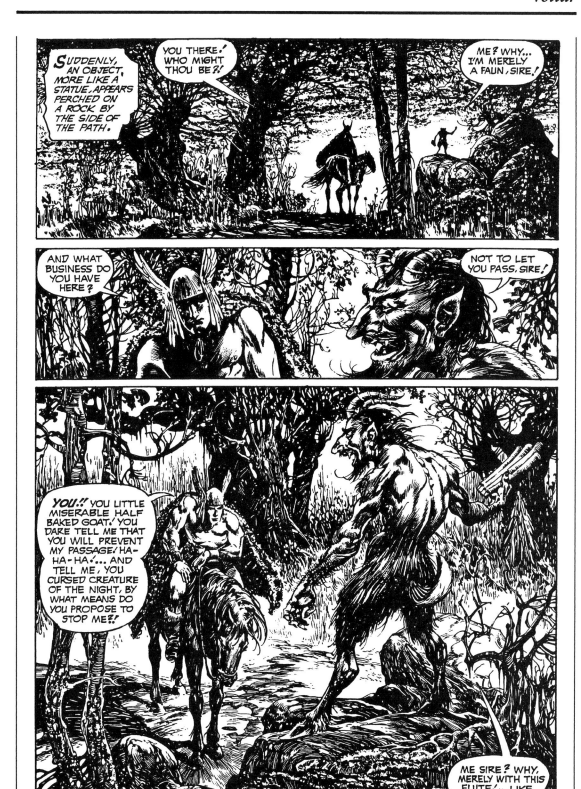

struction, giving it more definition.

Once again, I tried to make the creature strange, not like us, more wild and unshaven. They're half-human, half-animal. I wanted to make the new figure on this page more inter-esting than Voltar, because the leading man is already established. Once I've already inserted a character, I want to establish the newer char-acter, be it human or creature, in a strong and definite way.

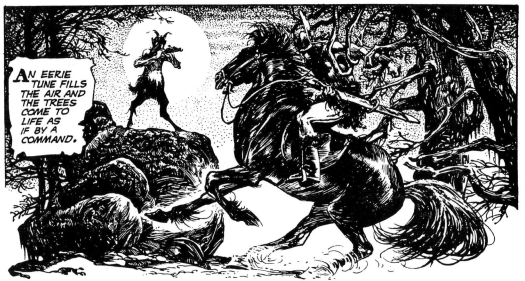

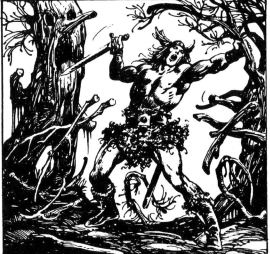

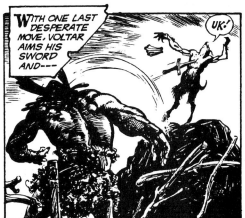

of the silhouette.

The next panel has a white background to show how the branches have come to life and are moving. I didn't want to do a heavy, ornate background in this panel because you would lose that sense of motion.

In the third panel, I put Voltar in a silhouette from a back view, with a few highlights to show his anatomy, but the satyr, though again a small figure, is noticed right away because he's silhouetted against the background.

I could have staged this panel many ways—I could have reversed the angle, for instance. The reason I chose this angle was to make Voltar the focus, and also his physical superiority. It also shows that he has hit the creature. In the next panel he is down already—the satyr has dropped his flute and the sword is through him. To Voltar, this is a solemn moment, because suddenly there are no more signs of life. This is also the opposite of panel 2, where everything is curved, moving. The heavier background shows that the satyr is motionless.

In the last panel the drama has wound down, so the best thing is to portray the scene with light and shade.

Here I use the full moon as a element of the storytelling again. I use the moon as a white area in the background and put the satyr in silhouette to make it more interesting. The figure of the satyr is much smaller than Voltar and his horse, but you notice it first, because

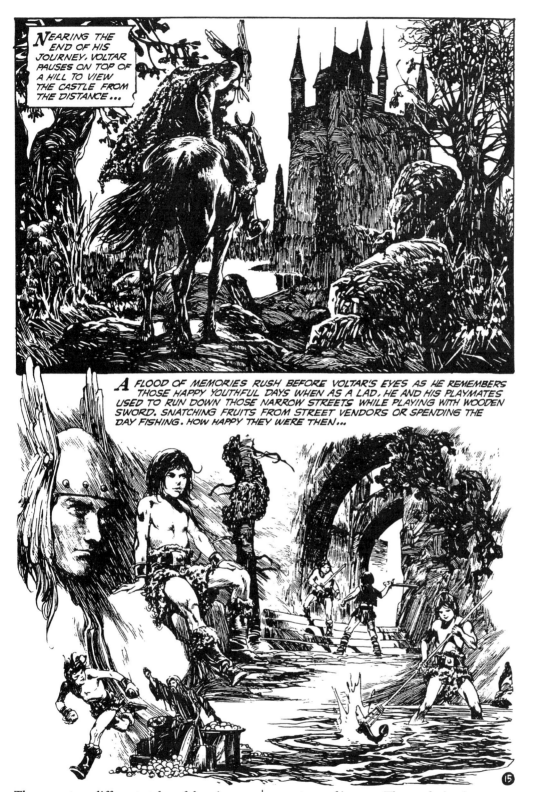

There are two different styles of drawing on this page. The top panel is very realistic—you see him approaching the castle, so you see the rocks and trees, the back view of horse and a man.

The second panel is a flashback, so I used a montage of images. The rendering is not as dark as the one on top, to keep things looking different. This part is more like a dream. The panel on top has a more solid, realistic feeling in the rendering, while the second one is more impressionistic, with more white space.

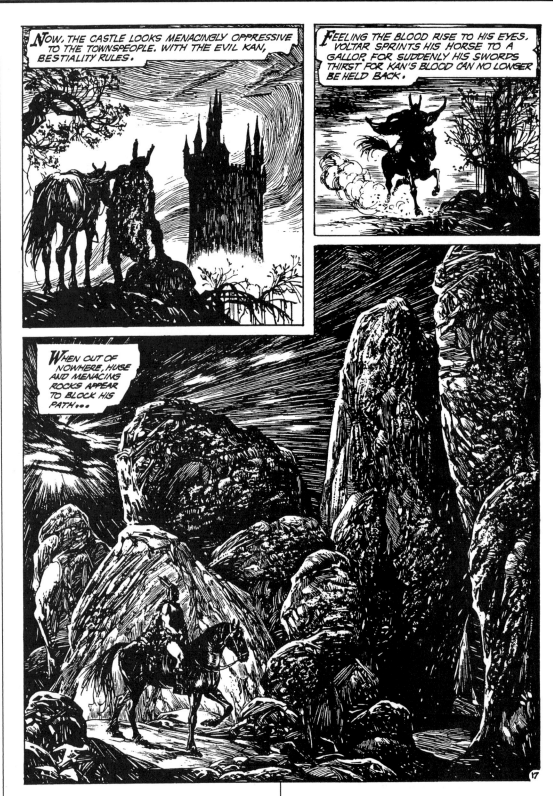

I only show things in outline in the first two panels. I used the silhouette because now you don't need to show Voltar's face and armor. You already know he's the hero, so you can identify him even in silhouette.

The focus in the first panel is the castle in the distance. The rocks and trees are of secondary interest. In the next panel you see the cape flying, and all the dust, but the tree is there just to fill up a blank spot, to paint the landscape.

The last panel is very dark and oppressive. Voltar is heading towards even greater danger, and the mood is very mysterious. He's wondering what lurks behind everything. I tried to get a strange mystic feeling in the rendering. It doesn't look like a typical wonderful landscape. If you take out the horse and the man, and look at the rock and sky and the rest, you should feel that you wouldn't want to go into this place by yourself! There could be a creature waiting to attack or an ambush with boulders...I wanted to show the tension and eerieness of the scene. If the comic had a soundtrack, I would want to hear a rolling bass drum.

THIS PAGE

Now we have a scene of revelry. Everything in the first panel looks like regular partying, but I cut to a close-up of the girl looking sideways, to let you know something sinister is going on.

The panel where Voltar gets dizzy and begins to pass out has a different shape. I gave it a rounder, more feminine shape, if you will, because the antagonist here is a woman. In the back of my head I was even thinking of a woman looking in a mirror. The curved line also shows how Voltar is getting dizzy. It looks like the lines are getting dizzy, too. It gives it a completely different look.

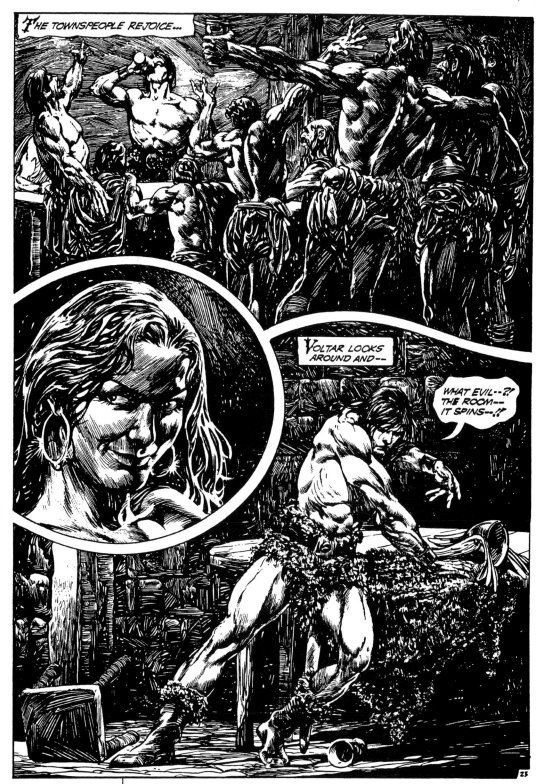

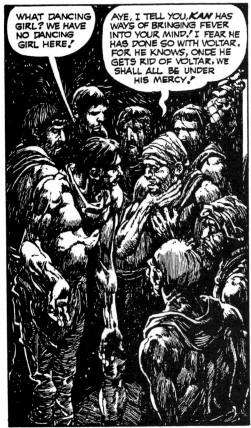

WHAT DANCING GIRL? WE HAVE NO DANCING GIRL HERE!

AYE, I TELL YOU, *KAN* HAS WAYS OF BRINGING FEVER INTO YOUR MIND! I FEAR HE HAS DONE SO WITH VOLTAR. FOR HE KNOWS, ONCE HE GETS RID OF VOLTAR, WE SHALL ALL BE UNDER HIS MERCY!

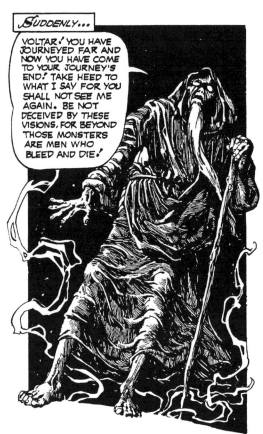

SUDDENLY...

VOLTAR! YOU HAVE JOURNEYED FAR AND NOW YOU HAVE COME TO YOUR JOURNEY'S END! TAKE HEED TO WHAT I SAY FOR YOU SHALL NOT SEE ME AGAIN. BE NOT DECEIVED BY THESE VISIONS, FOR BEYOND THOSE MONSTERS ARE MEN WHO BLEED AND DIE!

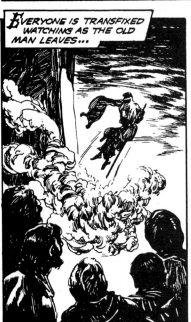

EVERYONE IS TRANSFIXED WATCHING AS THE OLD MAN LEAVES...

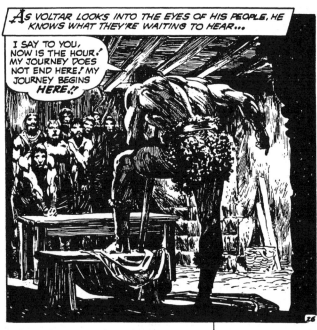

AS VOLTAR LOOKS INTO THE EYES OF HIS PEOPLE, HE KNOWS WHAT THEY'RE WAITING TO HEAR...

I SAY TO YOU, NOW IS THE HOUR! MY JOURNEY DOES NOT END HERE! MY JOURNEY BEGINS *HERE!!*

highlight his disappearance. In the final panel, I have the round fireplace, and the highlights on Voltar's body.

I'm always playing with the composition, trying for contrast. Although the first thing the casual reader notices is the rendering, it is always secondary to the composition.

FOLLOWING PAGE ➤

This page shows Voltar and his men entering the castle, and it's a good example of what is often called "cinematic story-telling"—a story told without the use of captions, or very few captions. Here, I tell the story through the pictures for the most part. With Voltar I tried to make it different from comics that tell the story though captions. You watch it as if you were watching a movie—a movie without sounds, true, but you can still follow the action very clearly.

The question arises as to why I broke down the action into four panels.

I was trying to prove with the storytelling that what you see is what you feel. Suppose you were entering a chamber like this. It's very quiet and spooky. The breakdown of the action into separate panels heightens the suspense.

A comic is like a movie in many ways, but you must remember a film shows real movement and a drawing does not. In a comic you don't know how a voice sounds, and there isn't any background music. But the trick is to cre-

Here again, you should be able to see how I'm playing with white and dark space to interest the viewer. I put a white border around the second panel to show the shock of the old man's appearance, to set him apart, and also just to get away from the usual square look. He's silhouetted in the third panel to

ate the movement in the drawings. By watching the drawings, the audience feels things are moving.

Today's comic book storytelling differs from the past. A lot of artists think they're being modern in a progressive way, but they still don't know how to involve the reader in the story. They haven't learned how to involve themselves in the story. Just involve yourself so you are really there, you are watching these people.

In all these panels, Voltar is highlighted, even though the scene is dark. In the last panel there's an example of how you can sometimes get away with "cheating." If you look closely, you'll see that the shadows from the fire on the right really wouldn't fall that way. But I illuminated it this way because it was more dramatic. It balances the composition. It's more dramatic because they've come from the darkness into the light. Pow! they burst out into the spotlight. But this is only a little "cheating." The lighting doesn't look obviously false.

One of my secrets is never to reveal things too soon. Involve yourself. Before you do the drawing, you must imagine: what if you were standing there, what are you watching? How did the others look? If I were there, I'd be

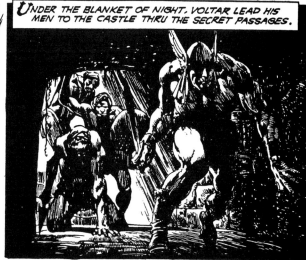

scared, and that's how I'd act. That's what I try to show.

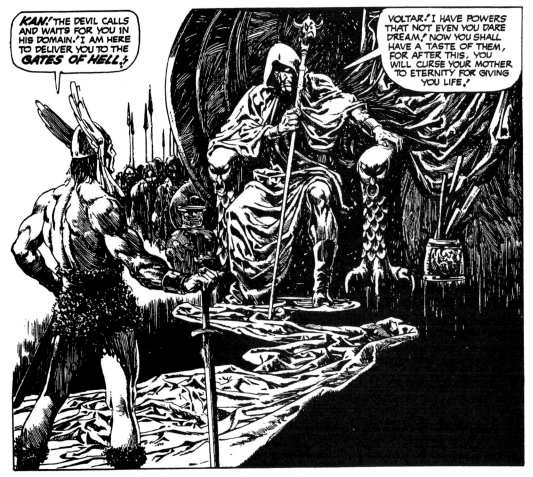

to have the eye go from Voltar to Kan. Always keep in mind how the eye is going to travel over the composition.

Sometimes you'll see artists show characters confronting each other, and just draw one on either side of the panel. That's not a new idea, and it's somewhat amateurish. You're the cameraman. If you just had a white panel, put a person inside and have him start talking, it's boring.

The two figures are the most important parts of the composition, but I also used the sword and the staff to create contrast. I had the sword breaking up the flow of the cloak because I don't like a solid line. If everything here were "just right", it would get boring.

In the second panel I tried for a more striking effect. Instead of just putting down an outline, it looks like the light was so strong that there is no contour, and the contour blends. Only the staff and the face stand out; the hood isn't important any more. This white, open panel is a big con-

This is the big finish, the big confrontation. I tried to contrast Voltar and Kan. One has a cloak, the other doesn't. The cloak on the floor helps to connect the two figures in the composition. Some people would say making the floor all black would be more spooky, but I wanted

trast from the top panel. Because it's a big change, you want to look at it. It's a shock.

FOLLOWING PAGE ➤

There a lot of sorcery on this page. Everything is swirling around Voltar, but he's staying calm. He's not scared, he's just steady.

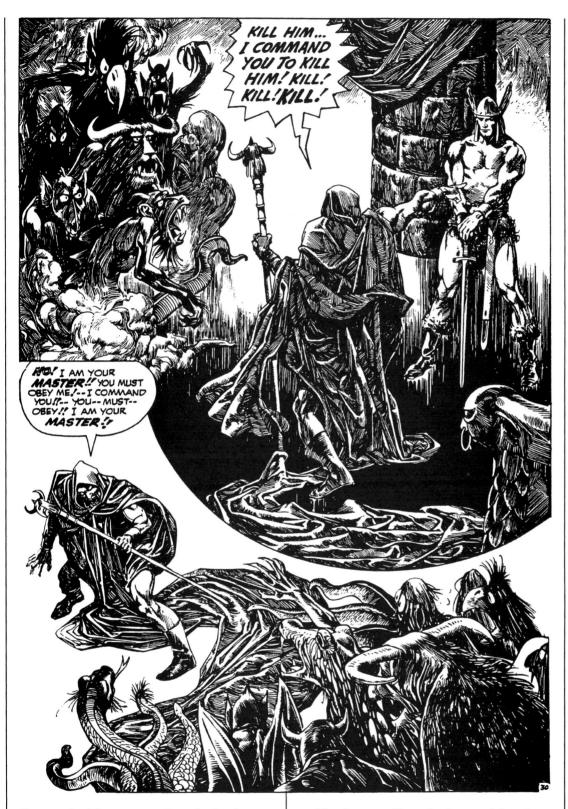

Once again, it's a contrast. I put in that large white space behind Kan so you could see the outline. I also took out the panel border. Voltar is highlighted with a lot of white, while Kan is mostly dark.

The first panel has a background, but the second one doesn't. I think of it as being like a musical background. The first panel has an organ playing. Then all of a sudden, in the second panel, there's no sound.

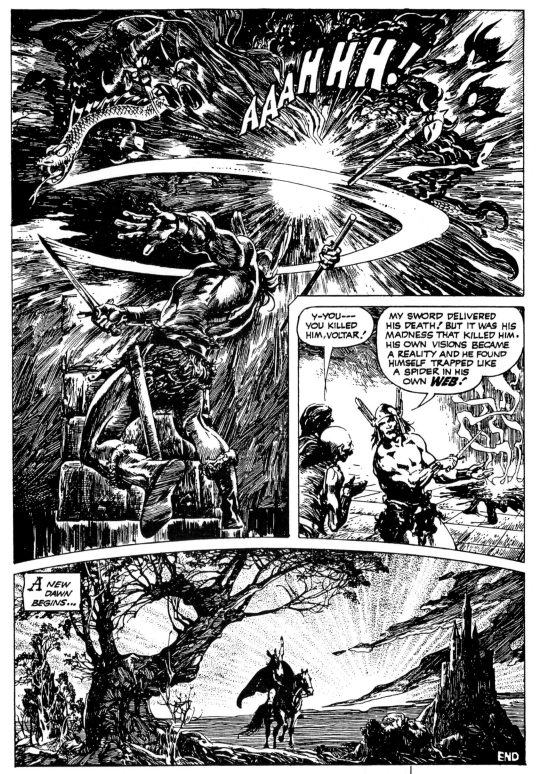

Here's the final confrontation. The white spot in the center is in the death blow, so it's a focal point. Voltar was very still in the previous panels, but all of a sudden, zoom!

In some ways it's like an ordinary fight. To be honest, this panel bores me a little; most young artists would be more excited by an action panel, but to me, it's just a standard thing. Books in the style of *Tarzan* or *Prince Valiant* have these kinds of scenes, but I try to avoid them. I try to get away from "the common". I call it common because you see it everywhere. That was my entire objective with *Voltar*: to tell the same story, but to show it in a different way.

The final panel is fairly simple. It's finished, the job is done, everything has wound down. I used pebble board for this. How come? For the setting sun, just to make it fade away, as if the music is also fading away, and he's riding off into the sunset.

Painting

Painting

Although a detailed exploration of painting is outside the scope of this book, the editors felt it would be of interest to discuss one of Alfredo Alcala's recent undertakings, the vibrant painting of a Filipino wood working shop which is reproduced on the back cover. Although he witnessed this scene in the 1940s, Alcala painted everything from memory, including the tools.

Q: What makes you decide on subject?

A: Well, with the painters in the Philippines, I haven't seen this kind of a painting with a crowd in it. Usually some artist will paint a carpenter, and it will be just one man swinging a hammer or sawing a piece of lumber. I wanted to show more of the scene, the tools and everything. This is what I observed when I was young—I became a carpenter, so I knew how to handle tools. The tools are drawn completely from memory, because these tools are only in the Philippines.

I remember this scene from when I was young. I remember the table they used for carpentry, I remember the vise, the C-clamp, the bench with the plane, the wood. I noticed that when they were working, the tools were all scattered around. The worker didn't arrange their tools or waste effort by sweeping around a lot, because there are constantly so many scraps and wood and sawdust around. I also remember that there was a house cat always playing nearby. And the boy standing with the mother? Maybe, and I only say maybe, I was that boy. But I planted him there—I was older than he is when I was watching this kind of scene, but just to make the composition, I put in the boy.

The wheel made out of a milk can—that was one of my toys when I was young. I built it myself. I remember the overalls, and I didn't like the strap hanging on my shoulder because every time I moved it got too tight. The wife is bringing the food to the workers. What's she's carrying is called a "pinbrera". It carries rice in the bottom, soup or stew in the center, and fried sausage or pork or fish or in the top.

Q: The boy is bringing vinegar?

A: Usually the Filipinos soak their fried food in vinegar.

Q: The little girl has bananas.

A: That's dessert. The little girl is talking to her Grandpa, telling him she brought his favorite dessert.

Q: How did you approach the drawing?

A: I did it in comic book style. I did a doodle, a small drawing. When I decided on the idea, I made a bigger drawing, with lots of erasures and changes in the movements of the people. I played with the positioning until I felt the idea was complete. Then I just inked it in a simple line, without color studies. Right away, I decided to scale it and blow it up, from 10 inches square to four feet square.

Q: So first you drew the grid on the paper, then you did the drawing, made a photocopy, drew the grid on the canvas, then measured it diagonally so you knew the center, and copied it.

A: Right. I had just done a line drawing, so the next problem was color. In composing the color, red and green shouldn't be near each other so I decided the woman on one side had a red skirt, and there must be no green around there. So the green should be over around the head near the window. I was trying to decide whether it would "pop" or not, since I did the sketch without any color breakdowns.

Q: *This is sort of how I see the composition: she's in red, and there's a curve of people. Your eye goes straight to her, but then your eye is going to be drawn around, and the painting unfolds.*

A: The grouping is the biggest problem.

Q: *How did you work out the grouping of the figures?*

A: Well, I actually learned that in the comic field. Usually I do this kind of grouping in a comic, where I avoid the center action.

Q: *There's kind of an unusual perspective in the painting.*

A: The perspective is because I was on a mezzanine [at the front of the painting].

Q: *Was it difficult to get this perspective?*

A: Yes, since I had to get the vanishing point. But this is the angle I remember.

Q: *How did you get the effect over there, where the tools almost look like a pen and ink drawing, but they're painted?*

A: I did the tools accurately in shape and line, then I rendered it in oil in color so it wouldn't get lost. This is really in the old style of painting. I did it with what I call the linear style, because as you can see there is a line on the contour of the person. Even the tools have a line around them. This is a style I admired by a European painter from a long time ago, but it's not really used much any more. You don't really notice it right away unless I tell people that it's the linear style.

Q: *Everything in this picture is so alive.*

A: Yes, I wanted everything moving.

Q: *Everybody's doing something.*

A: This took place in the late '30s, after the time of the Japanese occupation.

Q: *What other kind of thinking goes into a very complex painting like this?*

A: Painting is the highest step. Over the years, I've read biographies of many of the old masters, and no matter when they lived, in different times and places they all had the same idea. A painter should know how to draw, because if you know how to draw, the next thing you will do is color, whether you do it for a three-dimensional effect or not. But the drawing *must* be there. Now, I didn't understand that before. As I've matured, however, I've come to appreciate the realistic approach—it's not modern, because modern art doesn't really use proportions. But the artists I admire have been conservative artists, and things from that time have stayed in my mind: you must learn how to draw, draw, draw.

People ask me why don't you paint more and I say maybe later on. But the reason why is that I need to do drawings, because that's the first stage. What can you do with a painting when your drawing or sketch idea is very bad?

Some artists do sketches directly on the canvas. I could do it, but I prefer not to. Others who want to stick with painting must be sure that their memory is really good. Make sure that what you're doing is correct.

Q: *Do you recommend using a model?*

A: Oh yes, but if a model becomes expensive, artists can use a photograph. Don't copy the photograph, but use it as a base. If you're painting a woman's face you might look at a photo of an actress. Don't copy her, because it will just turn out to be a movie actress. Instead, follow the lines of the nose, the eyes, where the shade is located. It will be based on the photo, but it will be your vision. When you finish you won't recognize that the model you used is an actress.

Q: I believe someone like Norman Rockwell would have done this particular painting with a lot of models.

A: Rockwell used models as well as photographs. Later on when he became older, an old friend, told him "Norman, you are turning into a bad photographer" because his drawing by then was based on photographs only. Before he had been using the photos as a base only. To him, if he needed a model for a bum wearing an old hat, he would buy a new hat and exchange it with a bum. He'd tell the bum "I like your hat—you can have my hat, it's brand new."

Q: Cornwell's composition is astounding.

A: It doesn't look like a photograph. Rockwell used a model or a photograph from the start, but Cornwell used a model just to check.

Q: Wasn't Rockwell a fan of Cornwell?

A: They were good friends, actually. Of course, Rockwell became famous doing covers for the Saturday Evening Post. But Cornwell became an illustrator and a true innovator, because he had so much technique and style.

Q: Wasn't Dean Cornwell influenced by Frank Brangwyn?

A: Yes, he changed his style. He noticed that there was a British muralist who was pretty great [Brangwyn], so he went to England to study how to do murals. If you can find a print of his art from the late 20s and early 30s, you'll notice that his style changed then—it became more linear.

Q: How did you discover these artists?

A: Well, I knew Cornwell's work from the prewar days, and after the war, during liberation, there were lots of Life and Post magazines. Cornwell did a lot of advertisements about war.

Q: Did Cornwell and Brangwyn use models?

A: No, they did it in reverse. They'd compose the drawing, with a complete design. They'd blow up the drawing, and when it was finished, they'd bring in a model to check! "Fold your arm, bend your knee, sit down there." Maybe they'd say "Oh, there's a fold or a drape here. I was wrong!" They'd correct things by doing this.

Q: These masters did it from memory.

A: When they were questioned by others on how to become a good artist, they'd say, it's simple—you should have a good memory.

DOVER BOOKS ON ART INSTRUCTION AND ANATOMY

PAINTING SURF AND SEA, Harry R. Ballinger. (0-486-46427-X)

ILLUSTRATING NATURE: HOW TO PAINT AND DRAW PLANTS AND ANIMALS, Dorothea Barlowe and Sy Barlowe. (0-486-29921-X)

THE ENERGETIC LINE IN FIGURE DRAWING, Alon Bement. (0-486-47012-1)

WATERCOLOR LANDSCAPES STEP BY STEP, Wendon Blake. (0-486-40280-0)

ACRYLIC WATERCOLOR PAINTING, Wendon Blake. (0-486-29912-0)

PEN AND PENCIL DRAWING TECHNIQUES, Harry Borgman. (0-486-41801-4)

THE FIGURE IN COMPOSITION, Paul G. Braun. (0-486-48155-7)

ONE HUNDRED FIGURE DRAWINGS, Edited by George B. Bridgman. (0-486-47030-X)

THE BOOK OF A HUNDRED HANDS, George B. Bridgman. (0-486-22709-X)

BRIDGMAN'S LIFE DRAWING, George B. Bridgman. (0-486-22710-3)

PENCIL, INK AND CHARCOAL DRAWING, Charles X. Carlson. (0-486-46019-3)

CARLSON'S GUIDE TO LANDSCAPE PAINTING, John F. Carlson. (0-486-22927-0)

QUICK SKETCHING, Carl Cheek. (0-486-46608-6)

MARINE PAINTER'S GUIDE, Jack Coggins. (0-486-44974-2)

THE ARTISTIC ANATOMY OF TREES, Rex Vicat Cole. (0-486-21475-3)

LIGHT AND SHADE IN CHARCOAL, PENCIL AND BRUSH DRAWING, Anson K. Cross. (0-486-47733-9)

PRINCIPLES OF FIGURE DRAWING, Alexander Dobkin. (0-486-47658-8)

COMPOSITION: UNDERSTANDING LINE, NOTAN AND COLOR, Arthur Wesley Dow. (0-486-46007-X)

HUMAN ANATOMY FOR ARTISTS: A NEW EDITION OF THE 1849 CLASSIC WITH CD-ROM, Dr. J. Fau. (0-486-47024-5)

DOVER BOOKS ON ART INSTRUCTION AND ANATOMY

DOVER BOOKS ON ART INSTRUCTION AND ANATOMY

PERSPECTIVE MADE EASY, Ernest R. Norling. (0-486-40473-0)

FREEHAND PERSPECTIVE AND SKETCHING, Dora Miriam Norton. (0-486-44752-9)

SECRETS OF GOOD DESIGN FOR ARTISTS, ARTISANS AND CRAFTERS, Burl N. Osburn. (0-486-48041-0)

WATERCOLOR, John Pike. (0-486-44783-9)

DRAWING LESSONS, Willy Pogány. (0-486-45593-9)

BASIC DRAWING, Louis Priscilla. (0-486-45815-6)

HOW TO DRAW THE HEAD IN LIGHT AND SHADE, Edward Renggli. (0-486-45442-8)

LANDSCAPE DRAWING IN PENCIL, Frank M. Rines. (0-486-45002-3)

SKIES AND THE ARTIST: HOW TO DRAW CLOUDS AND SUNSETS, Eric Sloane. (0-486-45102-X)

TECHNIQUES FOR PAINTING SEASCAPES, Borlase Smart. (0-486-47699-5)

THE COMPLETE GUIDE TO ARTISTIC ANATOMY, John C. L. Sparkes. (0-486-47941-2)

DRAWING DRAPERY FROM HEAD TO TOE, Cliff Young. (0-486-45591-2)

DYNAMIC ANIMAL DRAWING, Arthur Zaidenberg. (0-486-47008-3)

DRAW ANYTHING, Arthur Zaidenberg. (0-486-47400-3)